IT'S ALIVE!

IT'S ALIVE!

A NOVEL

JULIAN DAVID STONE

GREENLEAF
BOOK GROUP PRESS

Published by Greenleaf Book Group Press
Austin, Texas
www.gbgpress.com

Distributed by Greenleaf Book Group

For ordering information or special discounts for bulk purchases, please contact Greenleaf Book Group at PO Box 91869, Austin, TX 78709, 512.891.6100.

Design and composition by Greenleaf Book Group and Lindsay Starr
Cover design by Greenleaf Book Group and Lindsay Starr

Publisher's Cataloging-in-Publication data is available.

Print ISBN: 978-1-62634-931-5

eBook ISBN: 978-1-62634-932-2

Part of the Tree Neutral® program, which offsets the number of trees consumed in the production and printing of this book by taking proactive steps, such as planting trees in direct proportion to the number of trees used: www.treeneutral.com

Printed in the United States of America on acid-free paper

22 23 24 25 26 10 9 8 7 6 5 4 3 2 1

First Edition

For Dad.

Five months until the first day
of filming on *Frankenstein*

One month until the first day
of filming on *Frankenstein*

"Bela Lugosi begs off from playing the
Monster in Universal's *Frankenstein*"

—*Los Angeles Times, August 1, 1931*

Two weeks until the first day of filming on *Frankenstein*

"Bela Lugosi or Boris Karloff as the Monster"

—*Letter from the director of* Frankenstein,
James Whale, to the film's lead actor, Colin Clive.
August 10, 1931

Three days until the first day
of filming on *Frankenstein*

This was supposed to be the greatest moment of my life, and now this
is happening!

The thought pounded through Junior Laemmle's head
as he caught the edge of the marble bathroom counter and
lowered himself onto the nearby toilet seat. Clothed in only
a bathrobe, he tucked his head between his hands, pulled
himself into a ball, and waited for the attack to begin.

It was going to be a day of triumph, and now, *this* arrived
like a minister at a petting party! Simmering, he knew it
would be just a matter of moments before his stomach would
begin pulsing with an uneasiness that would quickly spread
to the rest of his body, his breathing would become short
and clipped, and every inch of him would become covered
in a sheen of sweat as he collapsed onto the carpeted floor of
his private bathroom.

Today! Why today? The very day he was going to be
named vice president of Universal Pictures! He had held the

title of head of production for almost three years, but this promotion was going to be the icing on the cake, the proclamation to the mountains and the ocean and the sky—and all of Hollywood in between—that Junior Laemmle was the man to run Universal for now and as far into the future as one could possibly see.

But as much as Junior seethed, he knew he bore some responsibility for the impending attack. No one who took the risks he did got through them without some degree of suffering, and in a lot of ways, he'd been on a collision course to this moment, both the triumph and the attack, from practically the moment of his birth.

His father, Carl Laemmle Sr., always loved to tell anyone who was interested, and even those who weren't, that at the age of five, his son Carl Laemmle Jr. began to carefully critique each and every movie that his nascent Universal Film Manufacturing Company produced. Over the years, as both his son and studio grew in size, and each retelling of his father's became more and more fantastic, Carl Laemmle Jr. would merely shrug and state matter-of-factly, "Trust me; the old man and his movie company needed the help." Everyone would laugh.

Everyone except Junior.

Convinced his father was squandering the great potential his little movie studio had, Junior—even as his friends all headed off to various Ivy League colleges—went straight into the family business, producing his first film at the frustratingly old age of eighteen. There was no time to waste. Besides, making films had more kicks than a hundred

Harvard–Yale games put together! Soon, even his name took too long, and he was known to myriad actors, actresses, directors, writers, grips, gaffers, and production designers, as well as the numerous Laemmle family members in the studio's employ, as simply *Junior*.

Finally, on April 28, 1929, his twenty-first birthday, the old man put him in charge, making Junior head of all movie production at Universal Studios. "About time!" was all that Junior had to say on the matter, considering it one of the few smart decisions the old man had made in quite some time. With his thick brush of rich, dark hair always perfectly in place above his crisp face, and an ever-smiling mouth dominated by a top-heavy trapezoid of bright teeth, and his diminutive height of barely five feet forever making him look like a child wearing big-boy clothes, he went right to work.

But this was no simple time for Universal or for the rest of the film colony. What had started in 1927 as merely a whisper with *The Jazz Singer* had, by 1928, turned into a rabble, and then, by 1929, a full-blown roar. Talking pictures had arrived. And by the time Junior was put in charge of the studio, it was clear they were never gonna stop talking. The silent movie, with its wide-eyed lovers and over-the-top vamps, was dead and gone, and what the future held, no one really knew.

And that's when the fits first began.

Not because Junior was scared by the situation he'd been thrown into, but because of what he chose to do in the midst of the chaos.

Irked by what the old man had done—creating Universal Pictures' well-deserved reputation as the purveyor of cheaply

made movies for the uneducated masses gathered in the hinterlands—Junior pulled back on the cheap Westerns and pie-in-the-face slapstick and, with the freed-up cash, made quality films with big budgets for a sophisticated audience.

And it worked.

Month by month and film by film, with his foot planted firmly on the gas pedal and not a stop sign in sight, Junior transformed Universal. So much so that after a few months, the fits began to lessen and lessen, and then finally stopped altogether.

Until today. Friday, August 21, 1931.

Junior had been sitting in his spacious office at Universal Studios, listening to a couple of writers pitch him an idea for a movie, while a barber, manicurist, and shoe-shiner prepared him for the important events that lay ahead on this monumental day. With his eyes closed, he had been taking in the story while simultaneously running through the plan he had concocted to make the most of this auspicious occasion. Suddenly, out of nowhere, a small trickle of sweat formed on the back of Junior's neck, and although it had been a few years, he knew what it meant—it was the beginning of an attack, and he rushed out of his office, startling everyone, and disappeared into his private bathroom.

What could have possibly brought on this unwanted houseguest after so many sunrises? It was a big salad of bunk. Nonetheless, there he was, hunched over on the toilet seat, waiting.

But then, as the minutes ticked by, nothing happened. His stomach didn't hollow out, his breathing didn't become

choppy and short, and, with the exception of the back of his neck, his skin stayed cool and dry.

Nothing.

Why isn't it starting? Junior wondered, annoyed. The fits usually lasted five to ten minutes, and Junior wanted to get it over with. He had places to go and people to see!

He finally reached back and touched the wetness at the back of his neck that had signaled the fit's imminent arrival. The wet, clammy liquid not only covered the back of his neck but also had soaked the collar of his robe. But when he rubbed the liquid between his fingers, it felt a bit strange. Perplexed, Junior held his wet digits under his nose, and immediately his head jerked back from the smell.

Aftershave.

It wasn't sweat. It was aftershave. Junior closed his eyes and exhaled, annoyed with himself as he remembered that he had asked his barber to do something extra-special, as this was such a big day. Clearly, he had been a bit overzealous with the amount of aftershave.

Junior unfurled himself from the toilet seat and stepped over to the bathroom mirror. Eyeing himself, he broke into a soft chuckle. *Quite a show, kiddo, quite a show.* But there was no time to dwell on the ridiculousness of it all; Junior had a plan, and it was time to get back to it.

Junior hurried out of his bathroom and back into his spacious office, startling the half dozen occupants who had been quietly murmuring to themselves since his unexpected departure. "Sorry about that . . . ," Junior offered without breaking stride as he crossed back to his desk. "I went

a bit boffo for the oysters at Musso's. Let's get back to it. Quickly. Quickly."

Junior dropped back into his padded chair and reclined as the barber, manicurist, and shoe-shiner instantly went back to work on him. Behind him, through a bank of polished glass windows, tucked against the Hollywood Hills like a dog sleeping next to its owner, was the entire splay of Universal Studios. Everything that you could possibly need for the production of motion pictures—soundstages, production offices, workshops, bungalows, writers' rooms, editing suites, sound facilities, laboratories, and more—gleamed in the hot summer sun. Junior closed his eyes, taking advantage of the moment to rerun his plan in his head—it was just *perfect*, exactly what he was all about.

Someone cleared their throat, and Junior's eyes popped back open. Across from the stacks of production updates, box office reports, and written correspondence that covered the top of his desk were seated two men. Junior was quite used to the sorrowful physical state of writers, but this pair really took the cake. Both had anxious, over-eager smiles plastered on their faces, more than a little reminiscent of Laurel and Hardy—or in this case, Hardy and Hardy, as both men were quite chubby with tight-fitting suits. And both had the stooped shoulders and pale skin of a life spent indoors, hunched over a typewriter. Junior nodded in remembrance. "Gentlemen. Where were we?"

"You were about to tell us what you thought of the story we pitched you," the heavier of the pair, Tommy, answered.

"Right. Right. What was it called again?"

"*Hearts on Broadway.*"

"Right. Right. Well, let me tell you, gentlemen, I've heard a lot of pitches and—"

Suddenly, the door to the office swung open, and Mrs. Brown, a curt woman of forty with the patrician good looks of someone who once probably dreamed of being an actress, hurried toward Junior.

Junior shot up in his chair. "He's here?" he asked eagerly.

Mrs. Brown shook her head. "No. Not yet. It's Mr. Lugosi—his agent says he won't come to the phone. He swears he's not screwing with us. He's with Bela, at his house, and insists he doesn't want the part."

"Oh." Junior pursed his lips and sank back in his chair. "So our little game of cat and mouse goes on." Junior grabbed one of a pair of glossy black-and-white photos that floated atop the clutter of his desk like twin cherries on a sundae. He stared bemusedly at the intense headshot of the glowering Hungarian actor Bela Lugosi. "You're up on two wheels, Bela. And heading for the edge."

Junior's latest super-production, *Frankenstein*, was scheduled to start shooting on Monday, just three days away, and Lugosi was cast to play the lead role of the Monster. But Lugosi was a star, and he was doing what stars did best—being a handful of dust in the crankshaft. Despite a week of the studio reaching out, Lugosi was still proclaiming he wasn't interested in the role.

"Why can't I just let him go over the cliff?" Junior wearily asked Mrs. Brown. She didn't answer, and he didn't wait for her to. He knew full well it was all a contract ploy, an

attempt to leach more money out of the studio. And he also knew it was his own damn fault; he'd been the first to give Bela a seat at the table by casting him in the film *Dracula*— one of Junior's biggest gambles and, happily, one of his biggest successes—and that had made Bela a star. So with a weary acceptance, Junior sighed. "Call him back."

Mrs. Brown nodded, spun on her heels, and headed away.

But before she reached the door, she saw, through a window, a slender dark limousine snaking its way down Lankershim Boulevard toward the studio. Mrs. Brown spun around on her heels. "Junior, your father is—"

"I see him," Junior said brightly, his eyes watching the ten-years-out-of-date Pierce-Arrow wheeze its way past the front of the studio. This was it. This was the moment. The old man was back at the studio, and that meant just one thing—Junior was in the chips.

"Forget about Lugosi!" Junior bellowed at Mrs. Brown, dropping the Lugosi headshot back onto his desk; it landed next to the headshot of an actor named Boris Karloff. Junior had allowed quiet discussions about delaying the start of shooting—after all, that just meant more time to make the movie even better—so it was an easy decision. "Call the crew. Tell them we're pushing the start date of *Frankenstein* back one week."

Mrs. Brown nodded and hurried away.

Junior tore off his smock, sending the barber, manicurist, and shoe-shiner scurrying, and leapt up from his chair. He slipped behind a nearby dressing screen and pulled off his

robe, and immediately he was accosted by three valets who began dressing him.

Again, the sound of someone clearing his throat grabbed Junior's attention, and he peered over the dressing screen. Two big, fleshy faces smiled back at him. "Sorry, boys. Where were we?"

"You were about to tell us what you thought of the story we pitched you," Bob, the slightly thinner of the pair, said.

"Right. Right. What was it called again?"

"*Hearts on Broadway.*"

"Right. Right. Boys, it's a great story. Just fantastic. Top of the mark."

Bob and Tommy beamed at each other.

"So great, in fact—Warner Brothers made it two years ago. And MGM the year before. And just last year, Paramount did it."

Bob and Tom sank down in their seats, their eyes finding the floorboards.

Junior reappeared from behind the screen, fully dressed in a dark-blue pin-striped, double-breasted wool suit jacket with matching pants, creased so sharp you could cut paper with them, punctuated with a slick, silver-striped silk tie. "As long as I'm in charge here at Universal, we don't do that sort of thing anymore. We do new things. Exciting things. Things that have never been seen before." Junior looked them each in the face for emphasis. "So next time, Bob, Tommy"—they both flinched from being called the other's name—"if you want me to fork over the jack"—Junior

slipped on a pristine blue-gray fedora, cocking the brim to one side—"bring me the future."

Junior burst out the side door of the administration building with no less aplomb than the mighty Ruth heading to home plate. Almost immediately, he was joined in step by a sleek, well-built man in his late thirties, with rich obsidian skin and thick, closely cropped hair that was just starting to gray. He wore a chauffeur's outfit, complete with dark riding pants, boots, and a driving cap.

"Everything set?" Junior asked.

Clancy Jones, Junior's driver, gave him a sharp nod. "Everything set."

"Aces."

With the studio in check, the preparation done, it was time for what Junior loved best. Action.

Up ahead, waiting just behind Junior's polished black Marmon limousine, was an open-back film production truck, overflowing with cameras, lights, and crew, ready to roll.

It was such a brilliant plan, and it produced on Junior that rarest of commodities in Hollywood, a genuine smile. This was a huge weekend for the studio, with his father back in town to celebrate twenty-five years in the film business. That, coupled with the inside scoop he'd received about the board's decision, along with his father's telegram saying he would be returning to the studio as soon as he arrived from the East Coast, meant only one thing. The

old man was going to announce Junior's promotion to VP in person.

But that was just the tip of the iceberg. Junior was going to have this glorious event filmed and then slipped into one of the studio's newsreels to announce to the world that Universal was marching forward, with Junior at the helm.

Clancy raced ahead and opened the rear passenger door. Junior sped up and was about to climb in when suddenly a thick middle-aged woman hurried over.

"Junior, a word," Louella Parsons intoned, after initially feigning surprise, as if it had been an accident she had run into him. Dressed in a well-tailored flower-print dress, accented by stylish shoes, white gloves, and an enormous hat clearly designed to get attention, she looked more like she was attending a garden party than skulking around a studio.

"How about many words, Louella?" Junior shot back, brightly. He did not share the deep disdain most of the town had for the gossip queen. In her, he saw a kindred spirit. Someone always looking to move forward. When other reporters started their own columns, Louella stayed ahead of them by jumping onto the radio. But today, he was in a hurry, so he moved to get into the limo. "Call my office. Let's set up an interview for next week. Sound good?"

With a move that would have made Notre Dame's four horsemen proud, Louella blocked him. "I've heard rumors about a lot of things going on here at the studio."

Junior relented. "I bet you have, Lolly. It's a big weekend. My father's back at the studio for the first time in a while, and all weekend we're celebrating his twenty-five years in

the movies." Then he paused and, for fun, gave her a wink. "And there might be one or two other surprises."

But that was as far as he wanted to go. After all, Junior wasn't naive; he also knew that talking to Louella was about as safe as walking into a house made of TNT while flicking a lighter. A tease was all she would get. He had a plan, and he intended to stick to it.

"Let's talk about *Frankenstein*." Louella fished a pad and pen from her purse. "Such dark and disturbing material. Are people really ready for something like that?"

Junior chortled. "Might I remind you of a little picture titled *Dracula*?"

"But what if that was just a fluke? Luck? People just curious because it was different? Or maybe everyone just fell for all the hokum. You know, the girls you paid to run screaming from the theatre at every screening."

Junior rolled his eyes, overplaying his annoyance. "Lolly, I assure you I have no idea what you are talking about. Where do you come up with this nonsense?"

But Louella just stared at him. She knew he was lying.

And he knew she knew. Though Junior and his father hadn't spoken to one another for the last year, and his father had kept his distance during the production of *Dracula*, he had definitely stuck a few fingers in during promotion. It was a decidedly pre-Junior campaign: a bevy of actresses hired in every major town, instructed to rise up at the first sight of Bela Lugosi as Dracula and then run screaming from the theatre— six shows a day, seven days a week. It was everything Junior hated. But he kept his smile in place. "Lolly, I can assure you it

was no fluke. It's the future. It's what people want to see. The motion picture has come of age, and the audience wants thrills like that. *Frankenstein* will be our greatest picture yet. And you can quote me on that."

"Or maybe the story has personal meaning to you?" Louella asked, eyeing him closely, not unlike a psychiatrist curious to see how a patient will react. "Maybe you feel a kinship to this monster? Running around, destroying everything in your path. Everything that is old?"

Junior sighed. "Or maybe it just happens to be the next picture on the schedule?"

"But what are the chances that you'll strike gold twice?"

Struggling to keep his smile, Junior sighed. Now he wasn't talking just with Louella Parsons but also with every other executive at every other studio in the whole lousy town. No one in Hollywood had thought that *Dracula* could be made into a movie. No one except Junior. And as crazy as everyone thought he was to make *Dracula*, they all thought it was even crazier to make *Frankenstein*. They were wrong then, and he knew they would be wrong now. But he didn't have time to keep arguing with Louella. He had bigger game to hunt.

Junior suddenly looked past Louella, over her shoulder, and feigned surprise. "That can't be Lew Ayres. He's supposed to be shooting in Malibu today."

Louella whirled around. In the distance, a well-dressed man, with a scabrously tilted hat, had a chorus girl cornered against a studio wall. Louella eyed the provocative sight with the subtlety of a starved dog eyeing a T-bone. "I've heard

whispers he was on the rocks with Mae Clarke." Practically licking her lips, she hurried after the engrossed couple. "Oh, Lew! Lew!" Louella taunted as she closed in on them.

The man turned around.

It was not Lew Ayres.

Louella froze in her tracks. "Oh." She spun back around. "Junior, that's not—"

"I guess I was right. It can't be Lew Ayres." Junior waved to her. "Gotta go, Lolly." He slipped inside the limo. "The future waits for no man! Enjoy the rest of your day on the lot!"

Clancy hit the gas, and Junior fell back against the rear seat. The sight of Louella getting smaller and smaller in the rearview mirror made Junior laugh. As he settled in for the drive across the studio to where he was to meet his father, Clancy reached back through the small window that separated them and handed Junior a small rectangular wooden box. "This was dropped off for you while I was waiting."

Junior eagerly took it. Opening the top, he pulled out a gleaming dark bottle of alcohol and happily hefted it in his hand. "I've always said, Clancy, that the most important person to get to know on the lot is the studio bootlegger."

Clancy laughed. "I would tend to agree."

And it wasn't just for scoring booze. Junior was barely a teenager when he figured out that the one person who truly knew what was going on around the lot was also the studio bootlegger.

Happily, for him, during this past week, said bootlegger just happened to be on the East Coast picking up

a shipment, and while he was restocking all the Universal New York City executives, he had heard about the board meeting and Junior's upcoming promotion. He passed on the information to Junior, who thanked him for the tip and followed that with an order for the best bottle of champagne he could find.

"Moët '11," Clancy said, catching sight of the bottle label in his rearview mirror.

"Yes," Junior said, raising a bemused eyebrow. "I wouldn't have taken you for a wine expert, Clancy."

He smiled. "No, sir, a nice cool beer is more to my liking, but I did drive for Von Stroheim for a few years. One does tend to pick things up." Clancy whistled in admiration. "Moët '11. You truly are celebrating something big."

"I am, Clancy. I surely am." But it wasn't just the promotion. It was what the promotion meant. No more doubting him. No more second-guessing. No more conversations like he'd just had with Louella. This would shut up the naysayers for good.

Even the biggest one of them all.

From the moment Junior's father put him in charge of the studio, the fighting had begun. Which stars to sign, which films to make, where to shoot them, when to release them— battle after battle after battle.

But by far, the biggest fight they ever had was over *Dracula*. Their positions were as black-and-white as a well-exposed frame of motion picture film. Junior wanted to make it. His father did not. Junior felt this was the future, where the studio should be going. His father thought it

was disgusting material that Universal Pictures should have nothing to do with. Junior thought it would be a hit; his father thought it would flop.

Even now, as the limo snaked its way across the bustling movie lot, Junior could not understand his father's fierce opposition. After all, Universal was the studio that had launched the career of Lon Chaney, the preeminent mystery man of films, and they had had two enormous hits with *The Hunchback of Notre Dame* and *The Phantom of the Opera*.

But even when Junior pointed this out, it fell on deaf ears. He even tried to mollify the situation by suggesting they market Bela Lugosi as the next Lon Chaney, figuring the old man couldn't resist that kind of hokum, but that did nothing to soften his opposition. Undeterred, Junior made the film without his father's consent.

It was a smash hit.

Junior had been right, and his father had been wrong. And now, the board was making him a VP. He had won the war. He would film the moment. Record it. Exploit it. But he would not rub his father's nose in it. He would just keep moving forward, and *Frankenstein* was next.

Suddenly, the limo came to a screeching halt, Junior catching himself just in time to avoid hitting the front seat. "What's happening?" he asked as he tried to peer through the front window from the back seat.

"Construction equipment, sir," Clancy answered calmly. "Should be gone in a moment."

Frustrated, Junior watched as some heavy equipment blocked the road ahead. It was a pair of bulldozers, busy

tearing down an old, decrepit stretch of wooden grand-stands. "Why are they still working on this? Those were supposed to be taken down weeks ago!" Junior knew this because he had personally signed the work order.

The old outdoor grandstands were where his father had once charged the public a quarter each to watch the filming of silents, with the open-air stages lined up in a long row so the gathered crowds could sit back and watch someone get a pie in the face, or tear up a Western bar in a brawl, or return home safely from the war to a tearful reunion. But that was the past. The silent film was dead, and the grandstands had to go.

Junior simmered. The bulldozers were going about their business, jabbing at the decaying wood, far too slowly for his taste. This was going to ruin the perfect execution of his plan. Finally, he exhaled sharply, reached forward, and put his hand on Clancy's shoulder. "Turn left."

Surprised, Clancy spun around to look back at him. "It shouldn't take that much longer," Clancy offered hopefully.

Junior shook his head. "We don't have the time. Turn left."

Clancy eyed him, a little worried. "Are you sure?"

"Yes."

"All right, then." Clancy spun the steering wheel, and the limo headed off to the left, away from the slowly disappearing wooden stands. Within moments, they entered New York Street, one of a host of open-air permanent sets that dotted the back lot of the studio. But upon passing the first brownstone, Clancy slowed the car. "Are you absolutely sure?"

"Yes. Go ahead."

"All right." Clancy continued forward, carefully.

New York Street was an artificial section of New York City that ran about five blocks, always ready for filmmakers to use when an outdoor city location was needed for a film. Emulating the real thing down to the last detail, it consisted of counterfeit street lamps, apartment buildings, stoops, and corner stores made of nothing more than cheap wood and plaster. But even though Junior knew it was all fake, when he first took over the studio, this section of the lot always seemed to play a part in setting off his fits. Hollywood was where the movies were made, but New York City was where the profits were counted. And where each and every one of his decisions ultimately would be judged. So Junior had started to avoid this part of the studio altogether—even as the years passed, and the attacks faded away, and Junior's tenure became an undeniable success.

But today, as they drove along, with the surrounding buildings rising up all around him, Junior took it all in, calmly. Just another part of the empire that he was saving, bathed in sunshine on a gorgeous California summer day.

The experience proved so wonderfully underwhelming that Junior's focus immediately returned to the job at hand as they passed the final street corner, leaving New York City behind and coming out onto a rural ranch area used for Westerns. They were now on the backside of the studio lot, and Junior leaned forward, as if willing the limo to go faster.

Passing quickly through a ravaged battlefield, a seaside village, and then, finally, the central square of a small European village, they finally arrived at their destination—the back gate of the studio. It was a simple, unadorned

entrance of mere chain-link fence, more befitting a factory than a world of magic and glamour, with a single lone guard.

"Stop! Stop!" Junior yelled. Clancy complied, and Junior was out the door before the limo had come to a complete stop. Behind him, the production truck also came to a stop. Junior rushed over and motioned up to the crew on the flat-bed. "I want one camera over there and a second one over there," he said, pointing dramatically. "Quickly. Quickly." The crew jumped off the back of the truck and went to work setting up equipment.

Junior turned back to the rear gate just as his father pulled in. It had long been his father's tradition, after he had been gone for a length of time, to first enter the studio this way. It had been, as far as Junior could tell, an unwavering tradition for the past fifteen years. With the guard stiffening out of respect for the return of the studio's founder, Junior watched the old man's limo pass through the gate and then come to a stop in front of his own, meeting head-to-head. Junior collected himself, put on his best ear-to-ear smile, and stepped over to greet his father as he stepped out of the chauffeur-opened passenger door.

Carl Laemmle was of the same diminutive height as Junior, with a big, round, inviting face that, even after living in America for almost forty years, still shone with the bucolic charm of his birth and upbringing in rural Germany. Now well into his sixties, the little bit of hair that was left on his bald head, when it was combed—which was rarely—was a stringy mess of thin, disjointed gray strands. In spite of being a man of some wealth, no matter what clothes he wore, he

always looked like he had slept in them the night before, and his whole presence seemed perfectly suited to middle age. Known as "Uncle Carl" to family, friends, and millions of movie lovers who had never met him, he had about him a remarkably even keel, possessing the same calm body language whether giving the go-ahead for a million-dollar film or happily attending a friend's daughter's third-grade play. Even the way he occasionally spoke his *w*'s as *v*'s, and his *–ing*s as *–ink*s, only added to his air of kindliness. Simple, unassuming, nonthreatening.

And every single bit of it infuriated Junior. To him, the old man was just like his studio—nice, sweet, unassuming, and completely out of date with what was happening in the film business.

Just feet apart, they came together face-to-face and exchanged warm smiles, followed by soft nods.

"Hello, Junior," his father finally said as a genuine look of surprise mixed with pleasure washed over him. "I was not expecting to see you until tonight."

Junior swept his hand in the direction of the scurrying camera crews. "I thought it might be nice to film your return," Junior answered nonchalantly, "given that this is such a momentous occasion."

The old man nodded. "Yes. Yes. You are right. Twenty-five years in the motion picture business . . . "

"Among other things," Junior said, mostly to himself.

Carl looked around. "Perhaps there are some animals or some people in costume we can bring into this. You know, liven it up. Maybe some cowboys and Indians."

Junior didn't say what he was thinking—that what his father was suggesting was exactly what he didn't want to do—but he softly waved him off. "No, no, this is just right."

A nervous newsreel director stepped forward. "We're ready to try one, Mr. Laemmle."

"Thank you," they both answered simultaneously and then shared an embarrassed smile.

"We're ready whenever you are," Junior said to the director, who quickly scurried back behind the camera. Junior hurriedly adjusted his tie, straightened his jacket, adjusted his pant legs, and stretched the muscles in his face.

His father merely cracked a smile, exposing a jumbled keyboard of uneven white teeth.

Looking at where they were standing and what the cameras were aimed to capture—the founder and his heir, standing majestically, with their magnificent studio splayed behind them, surrounded by the rolling hills of Hollywood—Junior knew this was exactly what he did want. "And feel free to say anything you like, anything that comes to mind. With the cameras rolling, I thought this would be a great time to . . . announce anything you might want to," he offered offhandedly.

The old man nodded slightly. "Not a bad idea."

"Action!" the director yelled.

The cameras started whirring. Junior faced his father and stuck out his hand. "Welcome back to Universal City. And congratulations on twenty-five years in the motion picture business."

"Thank you." The old man shook Junior's hand, and

then the two men stood looking at one another, shifting uncomfortably on their feet.

Junior eyed him, as if willing him to say more, but his father was silent.

"Cut. Cut!" The newsreel director hurried toward them. "Great. Great. Let me turn the camera around and get it from another angle."

As equipment was moved all around them, Junior blinked quickly, a bit confused. Maybe his father needed a little prodding. Junior turned to him. "Was there anything you wanted to add to what I'm saying?"

The old man shook his head. "I can't think of anything."

"How were things in New York?" Junior asked, prodding further.

"Fine. Fine."

"How did the board meeting go?"

"Fine. Fine."

"Any major decisions reached?"

His father shook his head. "No. But there were several things discussed." He eyed Junior a bit more closely. "Big, important items, but they decided to wait on anything major because I was coming out West."

Junior tried to hide it, but his smile flattened as it became clear that the information he had received was wrong. He hadn't been promoted. At least, not yet.

His father continued. "They want me to check things out, then report back. You know—see how things are going. How the studio is being run. Then they will make their final decisions."

So that's it? Junior thought as everything became crystal clear to him. They were waiting on a recommendation from his father. Fine; so be it. His smile returned. "Well then, you can report to them that everything's great. Couldn't be better," he offered brightly.

The old man took a slight step closer to Junior. "Really?" His head cocked to one side. "Tell me about this *Frankenstein*."

Junior smiled assuredly. "It's going to be our greatest picture ever."

As if smelling a skunk, Carl furrowed his brow. "A mad scientist building a creature from dead body parts. Who will want to see this?"

Junior stroked his chin with his hand. "Hmmm, where have I heard that before? Oh yeah, *Dracula*—our top-grossing movie of the year."

His father raised a finger in the air. "Or maybe it's what *you* want?" Then he aimed his finger straight at Junior. "Maybe you think *you're* the mad scientist, forging ahead when everyone else thinks he's crazy, sure that he's right, and knowing he'll be proved a visionary?"

Junior hung his head and exhaled sharply. "Or maybe it happens to be the next picture on the schedule?"

"Really?" his father said, his cherubic features suddenly melting into one of piercing suspicion. "I hear there's talk of pushing back the start date a week."

Junior opened his mouth to explain but then paused. Convincing his father—a man whose most common advice for improving a script was "put a dog in it"—that a movie could actually be made better and dramatically improved by

a one-week delay would be like explaining an airplane to a giraffe. He would have to find another way, because clearly there was one last battle to be won, and it had to be fought on the old man's terms. But if this was what Junior had to do to get what he deserved, then so be it.

"I have no idea what you're talking about," Junior said without skipping a beat. "We're not pushing back a week. *Frankenstein* starts shooting first thing Monday morning."

The old man looked at him closely. Even though they were eye-to-eye, Junior felt like his father was looking down at him. Finally his father's cherubic features returned and he smiled. "I'm very glad to hear that. It will make my time at the studio all the more pleasurable." He jabbed the air with his finger. "I will be particularly looking forward to Monday morning."

The director was back. "Okay, we're ready to get that again from another angle."

"You know what?" Junior said nonchalantly. "I think we got all we need the first time. Go ahead and pack everything up."

The director gave a firm nod and headed off to inform his crew.

Junior turned back to his father. "I guess that's it, Pop."

His father nodded. "Well, then, I should probably begin checking things out. Very nice to see you, Junior. I look forward to spending more time together tonight." The old man gave his son a final smile and then walked off. A Western was shooting nearby, and he headed toward it, his chauffeur quickly jumping back in his limo and following close behind.

Junior watched him go for the briefest of moments before rushing back to his limo. "Get me back to my office as fast as possible," Junior spat out as he jumped into the back seat.

"Yes, sir!" Clancy answered, dropping the limo into gear and speeding off.

Junior gripped the seat. As they hit a bump, the bottle of champagne jabbed Junior in the side; he smacked it away in disgust. Rounding a corner, the limo was suddenly swallowed up by its surroundings. Junior peered out the window. Clancy was retracing their exact route, and they were back on New York Street. Only now, as Junior pressed his face up to the window, it had become something completely different—cold, empty, dark, the tops of the buildings blocking any sign of the warm, bright sky. Shadows danced everywhere. Angry shadows. Dangerous shadows. Judging shadows.

Junior felt something on the nape of his neck. Fearing the worst, he reached back to touch it, instantly feeling moisture on his fingers. He brought his fingers forward, praying he would smell aftershave, but before he could get his digits to his nose, a punch to his stomach told him there was no need. The pain spread fast, and his breathing quickened. Now assured of what was coming next, he curled into a ball on the seat. Instantly, his whole body was covered with a quick, cold sweat as he gasped for air. He closed his eyes and tightened his body as the fit completely overwhelmed him.

When Junior finally came to, they were just pulling up at the administration building. Slowly, and one pained breath at a time, the fit lifted. Junior had no idea just how much

time had passed. Had it been a minute? Or maybe five? As he collected himself, he sat up on the seat. The sweat was disappearing, his breathing was returning to normal, and the hollowness in his gut was fading. But as the effects continued to dissipate and he took stock of himself, he found himself overwhelmed by something new.

Determination.

He was so close to what he wanted, to what he deserved, and he would not let his father take it away from him. Come Monday morning, whatever it took, his father was gonna find a studio running to perfection.

Inside the administration building, Junior rushed through the hallways, his feet pounding on the polished marble floor as he hurried past the doors of all his top executives. Approaching the door to his office, Junior was relieved to find Mrs. Brown dutifully at her desk. She was busy packing up her purse to head home for the day.

"Where do you think you're going?" Junior snapped.

She looked up, surprised to see him. "You said I could go home early . . ."

"Sister, that was a lifetime ago." He marched past her toward his office. "Call everyone back. *Frankenstein* shoots first thing Monday morning."

Seeing the intensity pulsing from Junior, Mrs. Brown dropped her purse and quickly reached for her phone. But then she stopped. "And Lugosi?"

Junior sighed. "Call his house again." Junior caught a glimpse of the outside through a window. Gone was the boundless, clear blue sky, and in its place was a pack of thick gray clouds that were turning through the air like angry fists. There was no doubt about it. A storm was coming. And it suddenly dawned on Junior that perhaps a bit more would be required. "On second thought, about that call to Lugosi . . . "

"Yes?"

"One other thing . . . "

........

"I em Dr. Mirakle, messieurs and mesdames. And I em not a sideshow charlatan." Bela Lugosi let his words hang in the air as he considered his delivery, finally shaking his head, nonplussed. *I can do better*, he thought. Bela sneaked a peak at the script in his lap and looked up, fixing his gaze forward, as if addressing a crowd, and sweeping his arm magisterially. "I em Dr. Mirakle, messieurs and mesdames," he said again. "And I em not a sideshow charlatan." Finished, he considered his words again. *Better. Yes, better.* He managed a slight smile, followed by a few shallow nods. *Much more to be done, but better.*

Bela was seated on the couch in his comfortable home, just over the hill from Universal Studios, on Santa Monica Boulevard in Hollywood. An elegantly handsome man in his late forties, he had a full head of thick shoe-polish-black hair and a smooth, symmetrical face. Though he had

lived in America for almost ten years, he refused to hide his upbringing in Hungary and instead embraced it, carrying himself with a thick aura of European dignity. Dressed in a crisp white robe, cinched at the waist, over a pair of precisely pressed trousers, he was a perfect fit for his ornately furnished living room. There was no fixed style, just a sense that everything—from the carved wooden side tables to the brass hanging light fixtures to the stuffed leather ottoman— was in the precisely perfect spot. With the sun just about to set, a stab of light seeped through one of the curtains, landing on the wall just above Bela's head and highlighting the room's most eye-catching artifact—a large painting of a fully nude young woman.

The painting was one of Bela's prized possessions, and he particularly liked it when people would say, "You know, that looks a lot like Clara Bow," because it gave him the chance to answer, "That is because it is Clara Bow." Naturally, the next question would be "Why do you have a nude painting of Clara Bow on your wall?" At which point, Bela would simply change the subject, giving the whole exchange a salacious air. Not that the truth wasn't pretty darn salacious on its own.

As the finger of light crept across her rose-pink nipple, Bela eyed his script again. He straightened up, ready for another attempt at the line. "I em Dr. Mirakle, messieurs and—"

The phone rang in another room.

Bela sighed, irked. He knew exactly who it was. He'd always wanted a good agent, one who would fight tooth and nail for him. After the movie version of *Dracula* came out

and was a hit, he finally had gotten one. But this was getting ridiculous. His agent had been at this house all afternoon, pleading with Bela to take *Frankenstein*, but Bela steadfastly refused. After he ignored what was surely Junior's final call, he sent his agent away, telling him to get an early start on his weekend trip to Big Bear. His agent had reluctantly agreed, with Bela having to practically throw him out of his house. But his agent didn't stop there; he called twice from the road, imploring Bela to change his mind.

The phone rang again.

And now, he was trying again. Bela listened as his butler answered the phone; annoyed, he tossed the script onto a pile of Hungarian newspapers that cluttered the couch next to him.

A moment later, Morlan, a tuxedo-clad butler, paused at the doorway to the room. "Sir, if you'll pardon the interruption, there's been a call for you," Morlan said with a respectful nod.

Bela rolled his eyes. "And vhat did Mr. Thompson of the William Morris Agency have to say this time?" he said, his thick Hungarian accent exchanging the *w* in "what" for a *v*. "I am making a mistake? I must change my mind? I must take this role, this *Frankenstein*?" Bela continued wearily.

"No, it wasn't him; it was Junior Laemmle."

"Junior Laemmle?" Bela's head jerked back in amusement. "Junior Laemmle is trying again too?" Bela swiped the air with his hand. "The answer is still 'no.' I will not play Frankenstein. Tell him vhat I said before. I do not vish to come to the phone."

Morlan shook his head. "He doesn't want you to come to the phone. He says he's coming over here."

Bela Lugosi furrowed his brow. "Vhat? I do not understand."

Morlan stiffened to attention. "Mr. Laemmle did not want to talk to you on the phone. He is on his way over here. He said he will arrive in thirty minutes."

Bela tilted his head upward and rubbed his chin. *So Junior Laemmle is on his way over to see me.* Both of his cheeks rose as he grinned. *So they finally show me some respect!*

As Morlan began to move around the room—opening curtains, adjusting the furniture, straightening book-shelves—Bela rose to his feet. A true sign of respect from the studio. It was about time!

"Vhen you are done with all that, prepare some brandy— the good stuff from the back of the pantry," Bela said, now smiling.

"Yes, sir."

"And then give my leather loafers a quick shine and bring them to me, along with my burgundy smoking jacket."

Morlan nodded his acknowledgment of the order, fin-ished with his preparations, and hurriedly left the room.

Bela removed his robe, revealing a white shirt and tie underneath, and waited for Morlan's return. He paced, excited. It had been a long journey to this moment, filled with more ups and downs than a weekend drive to Ojai. He had become a star on the stage in the play *Dracula*, only to be initially looked over for the film version. After much lobby-ing on his part, and after everyone and their dog had been

considered first, Universal hired him for the film version. The movie had been a smash, making Bela a movie star, but still, he was shown no respect—still relegated to small roles, third and fourth leads, the type of thing for someone new, not someone who had proved himself to the studio. Then, finally, after months of waiting, he was offered a lead role, the Monster in *Frankenstein*. There was even talk that they were going to groom him as the next Lon Chaney. This infuriated him. The next Lon Chaney? How about the first Bela Lugosi! But he let it slide, happy to finally land a lead role.

Then he read the script.

His elation quickly turned to seething anger. The Monster was a deaf-mute, stumbling around for half the movie while everyone else got the lines. After all he had done for the studio, all the money he had made for them—this was how they repaid him? The role of a bumbling idiot covered in pounds of makeup? But again, happy to have a lead role and wanting to be a good soldier, Bela took the role. So how did Universal reward him? After preparing for the role and enduring a miserable makeup test, he was fired when a new director took over the helm of *Frankenstein*.

The only good to come out of all of it, and the only thing that kept him from wishing to burn the studio to the ground, was that almost immediately, he had been given another role, another lead, in a different movie for Universal. And this one was truly different; this one was wonderful. *Murders in the Rue Morgue* was an adaptation of a chilling Edgar Allan Poe story, and Bela had the best role in the movie. Dr. Mirakle, a mysterious man who was half carnival barker and

half wizard. A man filled with intrigue and darkness, just the kind of role Bela could really sink his teeth into. And best of all, he had dialogue. Lots and lots of dialogue. Page after page after page of words.

Bela was elated and chose to ignore the indignity of *Frankenstein* and, instead, concentrated on *Murders in the Rue Morgue*. He dedicated himself to mastering his lines and creating this marvelous man of mystery, Dr. Mirakle. Even with the start of production well over a month away, he worked at it every day, and just tonight, he was having dinner with the film's director, Robert Florey.

But then, like a winter cough you just can't get rid of, *Frankenstein* was back. With just a week to go before the first day of shooting, the studio wanted him again. For the role of the Monster.

This time, he refused.

His distaste for the role, compounded by all the jerking around, only hardened his resolve. Stars showed their faces to the world; they didn't hide them under pounds of makeup! And they spoke—words and words of great dialogue, not grunts and groans like a dumb animal. Day after day, entreaties were met with the same response, over and over, from Bela. No, the role of the Monster was not for him.

But now, as he paced excitedly in his living room, awaiting Junior's arrival, his resistance was beginning to fade. The studio was finally showing him some real respect. *Junior Laemmle is on his way over to see me,* Bela thought. *A studio head coming to see me! Treating me with respect, the way a star is treated! It may have taken months, but finally! I will hear*

Junior out. Maybe there is something to this role, this Monster, this creature who stumbles around, saying nothing, just grunting and groaning and—

No. No. *No.*

"Vhat am I doing?" Bela said, splaying his palms indignantly. "They treat me like dirt for six months, and then with one moment of respect, suddenly all is forgiven! *Frankenstein* is not for me. I am an actor. I have been a star on the stage for almost thirty years. And now a movie star! A true star does not forget how he was treated." He slashed the air. "Never."

Bela yelled into the next room. "Morlan!"

In a blink, Morlan entered the room, in the midst of wiping down an expensive wine glass. "Yes?"

"Bring me my tuxedo."

"Sir, I'm aware Mr. Laemmle is quite the VIP, but greeting a guest in your home in a tuxedo this early in the day—I would advise against this."

"I am not a puppet. I am not a doll that dances on the end of a string. I already had plans for this evening, and I am sticking to them. I am going out. Bring me my tuxedo. Now."

"But your dinner isn't for two hours."

"Then I vill enjoy a drink at the bar until my companion arrives. Bring me my tuxedo and my evening coat. I am going out. Now!"

Morlan nodded. "Very well, sir." He spun on his heels and left the room.

Bela stopped pacing and stood his ground, determined. His chest swelled, and he balled his hands into twin fists. "I am a star, so I must act as one!"

.

Halfway back to Universal, just off Highland Avenue, across from the recently opened Hollywood Bowl, Boris Karloff eased his battered Packard sedan into his tiny garage. He cut the motor, and as the wheezing engine sputtered to a stop, he collapsed against the seat. He was coming from a full day on set, acting in a film shot not far from his home at Columbia Pictures, and his whole body hurt. His perennially bad back was sore, his feet throbbed, and, most distressingly, his teeth ached. He was used to the first two ailments—they were a daily part of his life—but the third, the aching teeth, that only happened at times like this.

With a sigh, Boris pulled a few crumpled bills from his right pants pocket and placed them onto the well-worn seat next to him. He stuck his hand back into his pocket and pulled out a handful of scattered change. As he reached over to place the change on the seat with the bills, it clanged in his hands. A playful smile appeared on his face, and intrigued by the sound, Boris shook it again, and again, and again. *Ka-chunk. Ka-chunk. Ka-chunk.*

Using it as background music, Boris began to happily sing. "Oh Danny Boy, the pipes are calling." *Ka-chunk. Ka-chunk. Ka-chunk.* "From glen to glen, and down the mountainside," he continued, in the playful way only an Englishman by birth could sing an Irish ditty.

But then, as quickly as it had arrived, the momentary reverie faded, and he placed the change on the seat next to the bills and counted all of it. $19.47.

All the money Boris had in the world.

When would it ever end, this hard life of an actor? He appeared far more weathered than his forty-three years on this earth, with deep creases that lined his face, and the weariness in his eyes gave witness to the hard miles he had traveled. He still had a full head of thick hair, but it had begun to turn gray, and his once-golden coloring, so useful for the never-ending parade of exotic visitors from the Far East or Africa he was used to playing, had turned dark and leathery, making him appear more battered than mysterious.

It wasn't that Boris hadn't been poor before. He was an actor, after all, and living paycheck to paycheck was as much a part of the life as bad reviews and bad breath on costars. But for the last few years, he'd been riding high. Sound had come to Hollywood, and overnight, Boris's two decades of traveling the country in countless stage productions, performing in every town in North America with more than a dozen residents and a spare barn, went from something he avoided mentioning out of embarrassment to the first thing he brought up at auditions.

He'd started to work. A lot. They were small parts, and he was still a nomad—three days at MGM in Culver City; two days at Paramount, near downtown; a week at Tiffany in the heart of Poverty Row in Hollywood—but they paid well, and for the first time, he'd been able to actually save a little from each paycheck.

But like everything Boris had experienced up until then in show business, success began to fade. Now the town was flooded with actors who not only could deliver a line

without making a casting director cringe but who also had the right look. Work became scarcer. His current job wasn't bad, but after that, he had nothing. And as he looked at his meager assets, he sank further. He was back to this. He was back to having to spend his entire paycheck because when he was done with all his debts and expenses, there would be nothing left. Nothing that he could deposit in the bank.

Adding to his misery, as recently as just a week ago there had been a real chance that this endless cycle of being up and then down had finally come to an end. After a chance encounter with James Whale—a wunderkind director also from Boris's native England—in the commissary at Universal Studios, Boris had been offered the role of the Monster in the studio's upcoming production of *Frankenstein*. Boris was not familiar with the book, but when he read the script, he was delighted to discover this was not a small part but a major character in a major film for a major studio. There was even talk, as Boris sat for endless makeup tryouts and costume fittings, that they might market him as the next Lon Chaney! The next Lon Chaney? Fine with him. For six straight weeks of work, they could call him the next Theda Bara, for all he cared. But what gave him the real hope that this could be his big break, something that could really catapult him to success once and for all, were the conversations about the role that he had almost daily with his new director.

Both he and Whale saw the Monster as a scared child— not some horrific brute, terrorizing and destroying for the sake of terrorizing and destroying, but a frightened being,

searching for meaning and trying to understand the world he was born into. This sympathetic interpretation resonated with Boris and gave him real hope that he could deliver a powerful performance, one that would put him on the map, once and for all.

But now, that was gone. Someone else was going to be the Monster. Even though he had just landed the week's work over at Columbia, soon that would be over, and Boris would be out of work again.

And broke.

When would it ever end? All he had wanted for the last thirty years was to be a successful actor. Maybe it was time to face facts. Be a man. Accept reality. A sadness washed over him. Maybe it was time to move on and do something else with his life.

Defeated, Boris stuffed the money back into his pocket and wearily climbed out of the Packard. He slammed the door shut and stepped over to a stack of cardboard boxes that dominated the cramped garage. After lifting off the first two, he opened the lid of the third and fished around within. Finding what he was looking for, he pulled out a small rectangle of paper and, sighing, lifted it to his face.

Boris eyed the truck driver's license in his hand with pure dread. He hadn't needed it in years, and the memory of those hard times came back. It was the toughest job he'd ever had. The endless driving, the constant traffic, the nonstop loading and unloading—he'd hated every bit of it. But it was consistent, and it paid the bills. Right now, that sounded pretty darn good.

"Boris, is that you?" a familiar voice called from outside the garage.

Recognizing it, Boris quickly slid the license into his pocket, rearranged the boxes to their former positions, and exited the garage into the yellow-orange light of the setting sun. Dorothy Karloff, his wife, was hurrying down the long concrete staircase that led up the hill to their apartment. "Well, it certainly ain't Jack Frost," Boris said, forcing a playful smile.

"It is you!" Dorothy exclaimed brightly as she closed in. "Welcome home, darling." She was a stout woman, with pleasant, inviting features that had immediately attracted Boris when they first met, briefly, at a dinner party. But it was at a chance encounter a few weeks later, when he had been visiting the downtown library to check out a book of monologues, when he became completely smitten. Perhaps it was the good audition he was coming from or maybe the three days' work he would start the next day at MGM, but feeling ebullient, he asked her out on the spot. Three months later, they were married.

Reaching the bottom of the steps, Dorothy threw herself into his arms. She kissed him as if they hadn't seen each other in weeks. Boris kissed back, doing his best to hide his mood.

"The steaks should be done in a matter of minutes, and the baked potatoes right after. We can listen to *Amos 'n' Andy* while we eat, then we've got *The Happiness Boys* at nine and *The Ipana Troubadours* at ten. I'm so happy you're home!"

"Me too," Boris answered brightly, but his pain seeped through.

"What's wrong?" Dorothy asked, finally noticing his mood.

Boris took a deep breath. Even though he'd found out several days earlier, he hadn't told her. "It's *Frankenstein*—I didn't get it. They decided to go with Lugosi."

Her smile vanished into a mask of confusion. "But I thought the role was yours."

"So did I."

Dorothy shook her head, trying to comprehend. "But Whale discovered you personally. And all those nights at the studio, working on the makeup and—"

Boris gently raised a hand, cutting her off. "I'm just as surprised as you." Indeed, Boris was. Everything had looked so promising. He had been discovered in the cafeteria at Universal by the director of *Frankenstein*, James Whale himself. Then there had been weeks of makeup tests, all of them in secret at night, as he and the head of the Makeup Department for the studio had worked tirelessly on getting the look of the Monster just right. And now, it was all gone. "And just as disappointed."

Stunned, Dorothy's lashes fluttered rapidly. Finally, she mustered a sympathetic nod and wrapped her arms around him. "I'm so sorry."

Boris hung his head. "I really thought I had it. I really thought this was my moment. But in the end—"

"They went with a star."

"Yep. A star," Boris finally managed, spitting out the word as if it were a piece of gristle. A star. Just what he

wasn't. "At least I still have almost a week left over at Columbia," he added, trying—but failing—to make himself feel better.

Dorothy noticed and looked him straight in the face. "Boris, something big will come your way. I just know it."

Boris managed a weak smile. "Thank you." He knew how lucky he was; she was always so supportive of him. When they first met, when he was between jobs and things were slow, she had always been there with a warm smile after a failed audition. When things got better, one of the best parts of the success was not just the money but seeing how happy it made her. Boris could tell she loved this new world of crazy, eccentric show business folk who seemed to throw an endless stream of wild parties. She clearly found it exciting and loved every moment of it.

"I mean it," Dorothy added, moving to break their hug.

But when Boris tried to keep her close, she resisted. It was subtle, only a split second, but Boris knew exactly what it meant. He could feel it. He'd been through this before with other women—and other marriages. Like a fancy tablecloth coming apart to expose the old and battered table underneath, the truth was revealing itself. Unless you were one of the lucky ones, one of the chosen, being married to an actor was a hard life, filled with doubt and uncertainty and living paycheck to paycheck.

"Come now," she said, leading him toward the staircase that led up to their apartment. "We better eat. I have to be at school by eight."

"School?" Boris asked, stopping short of the steps. "I

thought we were going to listen to *Amos 'n' Andy* and *The Happiness Boys* tonight."

Dorothy shook her head. "I forgot that tonight was sign-up night," she said, averting her eyes. "I need to be there if I'm going to pick up some extra shifts." She started up the stairs.

There it was—acknowledgment that her dream of not working was gone. She was working evenings as a night-school teacher to help make ends meet, but with his being cast in *Frankenstein*, the plan had been for her to quit. Now, that was gone too. This was hard on Boris. Dorothy was really the first woman with whom he really wanted to build a life. A family. A future. But maybe it just wasn't to be.

At least, not as an actor.

Boris fingered the truck driver's license in his pocket and took a step toward her. "Dorothy, maybe it's time to consider other options."

She stopped, turned around, and looked down at him strangely.

Boris sighed, not wanting to say the words but knowing he must. "Maybe it's time for me to find something else to—"

The loud rumble of an approaching car interrupted them. They turned, both squinting, and were surprised to see a sleek black Marmon limousine making its way toward them. There was nothing wrong with where they lived—it was a perfectly nice neighborhood, filled with writers and actors just getting by—but this was the kind of car you saw triumphantly motoring its way up Laurel Canyon on its way to Pickfair.

Even stranger, as it drew nearer, Boris had the oddest feeling that he had seen it before. But where?

When it was almost on them, Boris and Dorothy eyed it closely, hoping to get a good look as it passed. But it didn't; instead, it began to slow. Then, just as Boris remembered that he had seen it on the lot at Universal, the limo stopped right in front of them, and Junior Laemmle hopped out.

........

Junior gave a final wave up to Karloff, who was standing about a hundred feet above him at the very top of the giant staircase that led to his apartment. Karloff returned the wave with one of his own and then headed out of sight.

It's done, Junior thought, grinning as he slipped into the rear of his limo and it pulled away, heading back to the studio. *Bold. Brash. Daring.* The words danced in his head. Junior knew that's what the newspapers would say after *Frankenstein* came out and was a hit. How else could they possibly describe what he had done by casting Boris Karloff, a complete unknown, in the role of the Monster? But that's how they did things at Universal now!

Nothing was going to stop him. Lugosi was out; Karloff was in. Keep moving forward.

He didn't know if Lugosi's not being home was unintentional or a snub, but he didn't care. He'd keep Lugosi in *Murders in the Rue Morgue*; after all, Junior did have to accept some responsibility for jerking Bela around—first wanting him for the role, then firing him, then wanting him again.

It all started when James Whale came aboard the project as the new director and didn't want Lugosi for the part of the Monster and picked Karloff instead. Junior went along with the change, as long as they could get another star for the film, and he went after Leslie Howard to play Dr. Frankenstein. But Howard was a well-ensconced star over at MGM, and the deal for a loan-out to Universal fell through. Whale quickly suggested another actor for that role, and Colin Clive came on board as Dr. Frankenstein. Junior was aware of his work and knew him to be a solid actor but not a star. Star power was still needed, so Junior turned back to Lugosi to play the Monster.

But now, circumstances had changed. Again. There was no more time for screwing around, and it was settled once and for all. Karloff would be the Monster. A new star for a new era!

As he reached the crest of the Cahuenga Pass, the sight of the houses that had begun to dot the mountains like a bad case of chicken pox only added to his excitement. He felt as unstoppable as the glorious city he lived in. Run out of room in the flatlands? No problem; we'll build in the mountains. Earthquakes? No problem; we'll build even higher. No water? No problem; we'll bring it in. No indigenous business? No problem; we'll bring one in from the East Coast. Trouble with a difficult actor? No problem; find a new one. Keep going, don't be stopped, and move forward, undaunted.

By the time Junior passed through the front gate of the studio, his exuberance put Caesar returning to Rome to shame. Clancy began to steer them toward his office, but

Junior leaned forward and touched his shoulder. "No. Over to Stage 18 first." Getting dressed for the banquet would have to wait; he was too darn excited.

Clancy drove them through a maze of windowless concrete buildings, each a massive, uninviting rectangle painted the same nondescript beige, until they reached the largest of them all.

The massive steel equipment door to Stage 18 was wide open, and once the limo stopped, Junior hurried inside. The indoor stage was a beehive of activity, with several dozen workmen hurrying about, setting lights, moving scenery, positioning sound and camera equipment. At the center of it all, bathed in the bleaching brightness of a long row of work lights, was a massive dirt mound shaped to look like a hillside graveyard, with several tombstones scattered about, encircled by a giant curtain that had been painted to look like a sunset.

As Junior crossed toward the massive set, the familiar smell of aging concrete and musty dampness brought a nostalgic smile to his face. The echo of his footsteps grew louder as, one by one, the busy crew members spotted him and stopped their work. The boss was here.

E. M. Asher, the associate producer Junior had assigned to supervise the production of *Frankenstein*, broke away from the group he was chatting with and rushed over to Junior. Everything, from the large stack of paperwork in his hand to his rumpled wool suit, was in a state of complete disarray.

"Junior, what is going on? One minute we're not shooting; the next minute we are?" E. M. spat out, not attempting to hide his exasperation.

"I know; isn't it exciting!" Junior shot back without breaking stride.

The only crewman who hadn't stopped working and was still busy rushing about, looking at the set from a dozen different angles, was James Whale. Even if he hadn't been the only one still moving, Junior would not have had any trouble spotting him. In a town where everyone spent every minute of every day trying to stand out, James Whale was a true original. He had made a big splash in his home country of England with his direction of the play *Journey's End,* a story set during the Great War. The filmed version, which Whale also directed, brought him to the attention of Hollywood, but with every studio after Whale's services, Junior had prevailed.

Barely into his thirties, James Whale had the dignified air of a retired nobleman and was always dressed and put together as if an unexpected meeting with the queen might occur at any moment. And today was no exception. He wore a perfectly pressed tweed jacket over crisp wool knickers that buttoned just below the knee, with bright argyle stockings that went the rest of the way down to his perfectly polished dress shoes. A true English gentleman.

"James, if I could have a word?" Junior offered as he caught up to Whale.

Whale lowered his hands, which he had been holding in front of his face as a framing device for a shot he was considering, and turned to look at Junior. A look of playful amusement washed over him. "Junior, how are you? Are we making a movie or not making a movie?"

"We are making a movie." Junior flashed him a knowing smile. "Most definitely making a movie. But there's more. Boris Karloff is going to play the Monster."

Whale's good cheer vanished, and his face fell. Through tense eyes, he just stared back at Junior.

Junior beamed. "Isn't that exciting?"

"Why would that be exciting?" Whale shot back.

Junior shook his head. "Am I missing something here? You were the one who found Karloff. You were the one who insisted he play the Monster—"

"Yes. Two months ago. And I started working with Karloff. But then, about a week ago, you insisted on going back to Lugosi when Leslie Howard fell out. I hated it, but you're the boss so I went along with it. I've spent almost every moment since then preparing to make this movie with Lugosi."

"So now go back to preparing for Karloff."

Whale eyed Junior with disgust. "'Just go back to preparing for Karloff. Just go back to preparing for Karloff.' We're shooting in two days, and you tell me to just go back to preparing for Karloff!"

"Yes."

Whale stared at him, incredulous. For a moment, it looked like he might actually reach out and choke Junior. "Follow me," he finally said, flatly.

With all eyes on the pair, Junior followed Whale about fifty feet across the studio to a rack of sound recording equipment.

Whale held out his hand to a slightly frightened sound technician. "Eugene, if you wouldn't mind?" Eugene

happily handed over his headphones and quickly moved away. "E. M., if you could get them to . . . " Whale lifted a finger and spun it in a circular motion.

"Yes, sir!" E. M. answered sharply and turned to the rest of the crew. "Come on, boys, let's fire her up!"

The studio exploded with activity as large movie lights were moved into position and turned on, props were placed and adjusted, and the background sunset curtain was pulled into position and tightened. Then everyone scampered out of the way, leaving Whale and Junior a clear view of the set.

"Tony, if you wouldn't mind, please grab the shovel and . . . " Whale pointed at the set.

Tony, a rotund stagehand in dungarees and a sweater, grabbed a nearby shovel and climbed up onto the dirt mound.

"Over by the grave, please," Whale added. When Tony reached the edge of a small grave that had been dug into the dirt, Whale raised a hand. "And stop! Perfect!" Whale then turned back to E. M. "Now!"

Suddenly, all the lights in the studio went out, except for the ones aimed at the set. In an instant, the generic dirt mound was transformed into a dark and dangerous hillside. The randomly placed tombstones became jagged daggers, stabbing frighteningly at the air, and the cloth background curtain became an ominous and foreboding sunset, making you wish you could run home and hide before the impending darkness of night arrived.

The transformation was breathtaking, even to Junior, who had spent his lifetime witnessing moments like this. He turned to Whale. "Very impressive."

Whale responded by handing Junior the headphones. "Now, put these on."

Junior did. And after a quick cue from Whale, Tony the stagehand began shoveling dirt into the grave. Now, along with the dark visage of a lone figure in a graveyard, filling a grave at night, into Junior's headphones came the sharp stab of metal sliding into earth. It was a frightening sound—with each jab, with each thrust, like a knife in the back. But there was more. After each slice into the earth, there was a thud as the dirt was dropped into the grave. This was not the soft sound of earth being placed on earth but the hollow, dead thud of dry, unforgiving dirt landing on wood. Dry wood. Hard wood. The wood of a casket.

Shunk. Thud. Shunk. Thud. Shunk. Thud.

It was a horrific image. A lone man at night, working at his dark task of filling in a grave.

Shunk. Thud. Shunk. Thud. Shunk. Thud.

An unknown grave. The grave of a stranger.

Shunk. Thud. Shunk. Thud. Shunk. Thud.

Or maybe your own grave.

Junior yanked the headphones off his head. Sweat dotted his brow. His pulse raced.

Whale cocked his head and pursed his lips knowingly. "See? These things take time to put together."

Junior sank, slowly regaining his composure. He knew Whale was right, but there just wasn't any other choice. "I understand; I really do," he offered. "But it has to be Karloff."

"They are very different actors. I have built my movie around Lugosi."

Junior shook his head. "It has to be Karloff."

"It can't be."

Junior put an understanding hand on Whale's shoulder. "I'm afraid it has to be."

Whale slapped the hand away. "Then I'm afraid you'll have to find another director." Whale nodded and gave a slight respectful bow, then walked away.

Junior shook his head, stunned. He was not expecting this reaction. By the time he recovered, Whale was almost to the door of the studio, and Junior took a step to follow after him. But then he stopped. He could chase him down and try to convince him. Maybe he would be able to, and maybe he wouldn't. But either way, he would lose precious time. Time he just didn't have. Keep moving forward. Onward. Lose a director? No problem; find another one.

But where?

.

At that very moment, not even ten miles away, in the heart of Hollywood, Bela Lugosi sat across the dinner table from a director of whom Junior was quite aware. Robert Florey was currently in the employ of Universal Pictures and was scheduled to be Bela's director on *Murders in the Rue Morgue*. He was a tall, high-waisted man of only thirty-one, and his penchant for baggy tweed suits, combined with his perpetually youthful fleshy pallor, made him seem more likely to be the class president of an Ivy League college than an experienced film director. But that was exactly what he was,

having left his native France almost ten years earlier with dreams of working in the film business and methodically rising up the ladder, rung by rung, to director.

Bela had liked him from their first meeting, a fellow European trying to navigate both the foreignness of America and the strangeness of Hollywood. With English being a second language to both of them, their dual-accented conversation might have stood out had they been dining anywhere else in town, but here at the Russian Eagle Cafe on Vine Street, they fit right in, as the place often resembled a washroom at Ellis Island. In fact, it was such a popular Hollywood hot spot to those stars who longed for a taste of their home countries that even the great Garbo, so reluctant to be in the public eye, would brave the stares of tourists and lesser Hollywood peoples just for a taste of the caviar.

The dining companions hadn't been there long, and over his salad of mixed greens, Bela was enjoying the looks of recognition he was getting from various passersby. The occasional studio executive had even stopped by to say hello—low level but a studio executive nonetheless. This was how it had been since *Dracula*, and Bela loved every minute of it.

Across from him, Florey buttered some bread before popping it into his mouth and looking around the room distractedly. At their previous meetings, he always had been bursting with energy and ideas, but today, he seemed a bit defeated and ill at ease, as if he wanted to be somewhere else. This concerned Bela because this dinner was more than just a social occasion to him.

An attractive blonde in a slinky gown passed the table, pausing just long enough to get Bela's attention. They shared some flirtatious eye contact before she moved on.

Florey noticed and perked up. "It must be nice."

"I have no complaints. There are certainly some—shall we say, nice benefits."

Florey leaned in conspiratorially. "What about the stories about you and Clara Bow?"

Bela swatted the air, as if dealing with an annoying housefly. "Stories—there are always stories." But seeing that Florey was finally showing some life, Bela steered the conversation to where he wanted it to go. "Robert, who do you think they will get to play my leading lady?"

Florey shrugged, losing interest in their conversation again. "I do not know. These days, I cannot get a meeting with Junior."

"That does not surprise me. I imagine Junior is quite busy these days."

"I'm sure he is." Florey then finally locked eyes with Bela. "With *Frankenstein*."

Bela nodded knowingly. "Yes. Yes."

A silence fell over the table, for the two men had more than just their foreigner status and upcoming production in common.

They both had *Frankenstein*.

They both were outcasts from the production. When Universal first announced that they would be making the film, not only was Bela supposed to be the star but Florey was also supposed to direct it. But when James Whale arrived

at the studio and decided he wanted to direct *Frankenstein*, Florey found himself shifted over to *Murders in the Rue Morgue*. It was painful, but he was under contract and had no choice, so he set about preparing to direct this new film. Shortly thereafter, Lugosi was let go too and rejoined Florey on the new project.

Florey exhaled sharply, his mood returning to his previous sullen state. "Sometimes I wish Junior would pay a little more attention to our film."

Bela tightened his eyes, seeing his opening. "Maybe sometimes you have to send a little message to let him know that."

"Do you ever wish you were still doing it?" Florey offered, still stuck on *Frankenstein*.

Bela eyed him for a moment. Did Florey know about Junior's recent attempts to get him back on board? No, there was no way. He glowered at Florey, annoyed. "Of course not! Why vould I waste my time with that? That only gives them power. All I care about is our film."

"But *Frankenstein*—"

"No! Our film vill be great. Dr. Mirakle—now that is a character! Not some stumbling oaf vit no lines. A man. A great man of science!"

Florey stared wide-eyed at Bela. "But he's so evil."

Bela smiled; Florey was finally engaged. "Yes, he is evil, and vhat he is doing is wrong, but I see him as merely misguided. A man trying to expand mankind's knowledge, only going about it the wrong way."

"Hmmm," Florey mused as Bela's words seemed to sink in.

"That is how I see him," Bela continued. "A great man

who started out with good intentions but vas driven astray by his own ambition."

"Yes. Yes," Florey said excitedly as he shifted in his seat. "What if some of what Dr. Mirakle was doing, in the hands of other people, might actually be helpful?"

"Very interesting."

"Yes. Yes," Florey continued, "what if we started on—"

A waiter approached the table, carrying a silver platter with the utmost precision. "Gentlemen, I apologize for the intrusion, but I have a note . . . "

Bela's first thought was of the passing blonde, but he quickly dismissed it. A waiter would have a short career at a place like this if he made a habit of taking notes from star-struck blondes to a dining celebrity. *Junior. It must be from Junior. He found out vhere I vas eating.* With the painful thought washing over him, he reached out for the note.

But the waiter held up a hand, stopping him. "With apologies, it's for Mr. Florey."

"Oh," Florey said, surprised, and grabbed the note off the tray. He read it quickly and then stood up. "Apparently, I have a phone call. If you'll excuse me, Bela."

"Of course," Bela said, with a bow of his head. "And when you get back, we vill talk some more about our movie. Then I just might remember a story or two about Miss Bow."

They shared a smile. Then Florey, with the waiter, headed away.

Bela watched them go. He was glad the note wasn't for him. He bet his disappearance from his home made it clear

to Junior that under no circumstances would he play the Monster. But by going to dinner with the director of another Universal project, he was proving he was a good team player. And dinner was turning out well. Florey was truly on board, and *Murders* would be stupendous. There would be no more talk of *Frankenstein*. He was an actor! He would be damned if he would play some stupid scarecrow.

Just as Bela was finishing the last bit of his salad, Florey returned. But now, he seemed distracted again, maybe even a bit harried. He sat back down, saying nothing.

"Everything okay?" Bela finally asked.

"I think so," Florey said, staring at his placemat. "It was E. M. He said Junior wants to see me."

Bela lit up. "Fantastic! He vants to talk to you about *Murders*! Vonderful!"

But Florey kept his gaze downward. "He wants to see me tomorrow. First thing."

Now Bela was the one musing silently. He gave a mild shrug. "He is a busy man. Perhaps it's the only time he has."

"I suppose so," Florey finally said, looking up but not mollified in the least. "Or maybe he wants to talk to me about . . . you know . . . ?"

"No, I do not," Bela said defiantly. "Now let me tell you some other ideas I've had for our little film." Bela straightened in his seat. "I see our film as a classic battle of—"

Abruptly, Florey shot to his feet. "I'm sorry, Bela, but I really should go. I-I need to prepare for my meeting with Junior." He dropped his napkin and, without another word, hurried out of the restaurant.

Bela watched him, concerned, before playing it off as nothing and returning to his salad. But with each bite of the crisp lettuce, his apprehension became harder and harder to hide.

........

Boris eased his Packard to the curb, cut the ignition, and hit the pavement with a hurried walk. He wanted to run, but he knew the sight of a large, gangly, bowlegged man sprinting down Hollywood Boulevard might bring unwanted attention that would only work against his goal. Reaching Vine Street, he made a quick turn and headed straight toward the entrance to the Hollywood Playhouse, a popular midsize theatre that was a favorite for traveling productions of hit Broadway shows. The play was just ending, and beneath the gleaming marquee, the first dribs and drabs of the crowd were exiting. Boris pushed upstream through them.

He quickly crossed the ornate lobby and then, standing behind the back row of seats, began to search the theatre. His eyes darted from the jubilant cast taking their final pleased bows onstage, to the excited crowd in the midst of their thunderous standing ovation, to the stream of exiting theatregoers happily heading straight toward him. It took a few moments, but finally the crowd thinned out enough, and Boris spotted his prey.

Standing in the third row, in a seat almost all the way to the side wall of the theatre, was a tall man with thick white hair and a neatly trimmed white mustache. This was

Stanley Gibbons, Boris's agent. Boris always had found him a bit of a slippery character—his number of wives, as well as his true age, always were subject to endless rumors—so it had taken Boris several hours and about a half dozen phone calls to finally glean his location. Pleased, Boris hurried toward him.

A mere three years earlier, the notion of an agent attending a play would have been the punch line of some drunken actor's joke.

But not these days.

Any show that came to town and, in particular, a show that had been a hit on Broadway—as was the case with this one—brought agents out in droves. If actors were in a play, you knew they could speak lines, and it saved you the time and disappointment of calling them into your office based on a headshot, only to discover that the chiseled leading man sounded as masculine as Mickey Mouse or the elegant Southern belle had the voice of a carnival barker.

In fact, just a year or so earlier, Boris himself had been discovered onstage in a production of *The Criminal Code* at the Belasco Theatre in downtown Los Angeles. He'd been a standout in the play as a brutal and violent prisoner named Galloway, and Stanley had quickly swooped in and signed Boris to his agency. For a while, Boris was the new kid on the block, and when he started booking some solid film roles right out of the gate, Stanley lavished him with attention. But as time passed and bookings became fewer and further between, the attention faded. In true agent fashion, however, when a role as good as the Monster in *Frankenstein* had

shown up on the horizon, Stanley found himself suddenly interested in Boris's career again. But when that disappeared, so had Stanley, leaving it to an assistant to call Boris and let him know he had lost the role to Lugosi.

The departing crowd thickened as he closed in on Stanley, and by the time Boris reached his seat, he was gone. Fortunately, Stanley was famous for wearing his trademark black bowler, and Boris easily spotted him as he hurried out a side door. Boris chased after him, following him to an outside alley, and finally caught up to him as they both joined the crowd at the stage door waiting for entrance to the backstage area.

"Stanley!" Boris yelled above the excited din.

About five feet in front of him, Stanley turned around, and after several seconds of searching the crowd for the source of his name being called, recognition washed over his pasty face. "Boris! How are you?"

"I'm fine!" Boris yelled back. "I need to talk to you."

"Yes. Yes. I've been meaning to talk to you. I'm so sorry about *Frankenstein*," Stanley shouted back at him, splitting his focus between Boris and a nearby doorman who was seated on a stool, busily checking names from a list before letting anyone slip by him and enter the backstage area.

Boris fought with the crowd to get closer. "Stanley, I really need to talk to you now. I've been cast again as—"

"Yes. Yes. Hell of a show. And what a cast!" Stanley said back to Boris as he reached the doorman and said something to him. The doorman checked his list and nodded, and just as Boris caught up, he let Stanley through.

Boris stepped to follow after him, but the doorman rose from his stool and blocked him.

"Name?" the doorman said flatly, looking straight into Boris's eyes to let him know he meant business.

"Please. It's important," Boris implored, trying to move past him as he watched Stanley disappear backstage.

"Name?" the doorman asked again, no less sternly and holding his ground.

Boris ignored him, and with Stanley almost out of sight, Boris pitched forward as far as he could and yelled, "I've been cast as the Monster again. In *Frankenstein!*"

No response. Stanley was gone.

The doorman put a large callused hand on Boris's chest and pushed him back. "That's enough."

Boris complied, taking a step back, and hung his head. He was about to turn and leave when Stanley suddenly reappeared in the stage door.

"You're back in *Frankenstein?*" he asked, enthralled and grinning like Boris was his long-lost best friend.

Backstage was a swirl of well-wishers, flowers, agents, reporters, and suitors; Boris followed Stanley until they reached one of the dressing rooms.

"Six weeks' work?" Stanley said, turning back to eye Boris, pleased. "That's good. That's good."

"Yes." Boris beamed back.

"*Frankenstein*? I thought Lugosi was doing it."

"Apparently not."

"Well, his loss is our gain."

"It would seem that way. However, I need to talk to you about—"

The door to the dressing room opened, and in the center of a few well-wishers was a rather stern, almost muscular-looking woman in her late fifties who had clearly just changed out of her stage clothes and makeup.

"There she is!" Stanley said brightly and loud enough to drown out any other conversation. With Stanley leading the way, he and Boris cut through everyone else in the room. "Boris, I'd like you to meet Betsy Crawford"—Boris and Betsy exchanged greetings—"or as I like to call her, the next Marie Dressler!"

Betsy nodded approvingly.

"Boris is another one of the actors I represent"—Stanley caught himself—"if you decide to give me the honor of representing you here in Hollywood."

Betsy gave him a big, open, we-shall-see smile.

"And he'll be joining us for drinks at the Derby."

This caught Boris by surprise, but he smiled nonetheless.

"Wonderful." Betsy turned to the others in the room. "If you'll excuse me." Betsy then turned back to Stanley. "Shall we?"

The three of them stepped out of the dressing room and, together, fought their way through the excited swarm.

"Uh, Stanley, I really need to talk to you—about *Frankenstein*," Boris said, trying yet again.

"I know; it's great news," Stanley answered and then turned to Betsy. "Boris here has just landed a major role at Universal," he said proudly. "It took a lot of work, but we got it done."

Betsy nodded, impressed.

Having had enough, Boris grabbed Stanley's arm. "It starts shooting on Monday, for six weeks."

"Six weeks' work!" Stanley repeated, making sure Betsy heard him. "That's wonderful."

"Yes, it is," Boris continued, "except I've still got a week on my current film."

"You're working now; that's great," Stanley said, again making sure Betsy heard.

"Yes, it's great. But I can't do both jobs."

Stanley swatted the air, as if dispensing with the most insignificant gnat. "Easy as pie. We'll just have you quit the movie you're doing right now. *Frankenstein* is your ticket to the big time, kiddo."

Boris looked down. "It's, ah, not that simple. My current film is *The Guilty Generation*."

Stanley looked at him blankly. "So?"

"It's for Columbia. It's for—"

"Ray Cohn." Now Stanley looked down too. It didn't seem possible, but his face turned even whiter. From the lowliest extra to the most powerful agent, everyone in town knew that Ray Cohn was the last person you wanted as an enemy. It was never smart to cross any studio chief, but no one was as notoriously vindictive as Ray Cohn. Walking out in the middle of one of his films or having one of your

clients walk out was just the way to end up at the top of his notorious blacklist. Stanley sighed. "Well, then, it looks like you're going to have to turn down Universal."

"But there has to be a way."

"Not if you want to ever work in this town again." Stanley snapped his fingers. "I just remembered; the reservation is for only two. I'm afraid you won't be able to join us, Boris."

"But, Stanley—"

"Call me when you're done next week at Columbia. I'm sure we'll find something else for you."

And with that, Stanley slipped his arm around Betsy and escorted her away. Boris watched them leave, and as he was swallowed up by all the backstage excitement, he wondered if his big break had also just gone out the door.

........

As his limo streaked along Wilshire Boulevard, Junior sat in the back seat, struggling to tie the bow tie of his tuxedo. But that was the least of his problems. He was more than a little late to his father's banquet at the Ambassador. The hotel was just a few blocks up ahead, but through the front window he could see them approaching an intersection just as the traffic light turned yellow. Junior opened his mouth to implore Clancy to run it, but before he could get a word out, he felt the limo accelerate and push him back into his seat. *Good old Clancy*, he thought as they shot through the intersection, and he returned to fighting with his unruly bow tie.

Even though he had come upon his tardiness honestly—
after all, it had taken some time to track down Florey and set
up their meeting for the next day—it still had angered his
date for the evening. She sat across from him in silence, her
body twisted away from him, staring out the window.

With a final twist of his fingers, he tied the bow tie.
Pleased, he turned toward her. "Ta-da," he said, like a proud
magician. But she still ignored him. And then a second later,
the bow tie came apart, the unraveling ends flailing like a
black octopus across his white tuxedo shirt. Junior's face fell.
"Oh, crap" was all he could manage.

Sidney Fox finally turned toward him and, rolling her
eyes, reached over and grabbed the bow tie. "Oh, for the
love of Pete!" she exclaimed as she quickly tied it and then
returned to her slouch and staring out the opposite window.

Junior tugged at the bow tie and then, assured it would
not fall apart, rearranged its position around his neck.
"Thank you; that's perfect." He hoped to take advantage of
the perceived thawing. All he got back was more icy silence.

But with his eyes still on her, he couldn't help but notice
that the way she was contorting her body had caused her
fur-collared light-gray evening coat to fall open, revealing
a tight white chiffon gown that accentuated her abundant
curves. His mind drifted back to when they first met.

Junior had spotted her onstage in a Broadway show.
The title of the play was long forgotten but not his first
glance of the diminutive beauty with a bob of rich dark
hair and perfect porcelain skin. That was forever etched

into his brain, and he was immediately smitten, both as head of production and as a man.

He headed backstage after the show and signed her on the spot. Their relationship began months later, after she had relocated to Hollywood, and Junior discovered her attractiveness went well beyond just the physical. At just twenty, Sidney may have worn the tight, short hair of a flapper, but that was where the comparison ended. There was no giggling and preening with Sidney, no "23 skidoo" and "the cat's meow"—that was strictly last decade. She was all about being modern. She understood; she knew the score. An actress and woman with no ties to the past. And that suited Junior just fine. One year and four pictures later, both her career and their relationship were still going strong.

That was why the icy silence between them was so strange. It had started the moment he picked her up. Sure, he had been late, but that had never bothered her before. She understood that he had a studio to run.

Sidney finally noticed Junior's staring and glowered at him. "Take a good look, Junior, because that's all you're getting tonight."

Junior threw his hands in the air. "Oh, come on, Sidney. Enough. I know this has to be about more than my picking you up late."

Sidney looked him straight in the face. "I need attention, Junior."

"Seriously? That's what this is all about? Didn't we just spend all of last weekend up in Santa Barbara together? I

know we knocked a few back, but I'm pretty sure we were both there."

"Not personal attention," she said forcefully. "Professional. My career."

Junior looked at her, incredulous. "You just finished a film two weeks ago."

"I know. And I'm going out of my mind. I need to work."

"My God, Sidney, you know I do have an entire studio to run."

"Really? Of late, it seems most of your focus is on *Frankenstein*."

Junior exhaled sharply. "It's our next production. Of course, things are a bit crazy right now."

Sidney shook her head. "This is different. There's been a lot of 'next productions,' and nothing has quite taken you over like this. You told me something was going to happen this weekend. Something big, for both of us. Well, the weekend's here. What is it, Junior?"

Junior looked away. She was right on this one. Junior had had big plans for the weekend, but now they had all gone up in smoke. But on the bright side, at least she didn't regale him with some crazy theory about the reason *Frankenstein* was so important to him. No messing around; straight to the point. It was about her career, and that was something he could work with. "Did you ever stop to think that some of this craziness might have something to do with you . . . also?"

Sidney peaked her eyebrows. "Go on."

"I do have something in the works."

"Do you, now?"

"I just might." Junior gave her his best smile. "You know I am a man of my word."

"I don't know about that, Junior. But you do have your moments."

"Yes, I do, and I promise you many more."

"Do you, now?" Sidney retorted playfully.

"You can take it to the bank." Junior gave her another warm smile; this time, Sidney returned it.

Just up ahead, the bright lights of the Ambassador beckoned, with a waiting throng of press and a cauldron of frenzied fans. As if cued by a stage manager, the two of them began preparing themselves as if they had done this dozens of times before—which they had.

Clancy pulled up right in front of the hotel. Junior and Sidney turned their bodies toward the door as they both assumed their roles—the young studio head and his beautiful actress date, ready for action.

The door swung open, and out popped Junior and Sidney. Immediately they were hit by an explosion of camera flashes and a wall of roaring cheers from the excited fans. Sidney took it in, smiling and posing like a pro. But Junior grabbed her hand and hauled her away, moving them quickly down the red carpet.

"What's happening? Why aren't we stopping?" Sidney asked, trying to simultaneously pose and walk.

"We have to go straight in. We're late."

"I know! And it's the best time to make an entrance. We have the fans and the press all to ourselves."

Junior knew she was right, and there was nothing he wanted more than to leisurely stroll up the red carpet with his beautiful leading lady on his arm. In fact, it had been part of his plan. He knew the press would take a ton of pictures, and when the story of his promotion finally broke, these images, being the most recent, would be the ones splashed across papers coast to coast—the brand-new VP of Universal Pictures arriving with one of his glamorous stars. But the promotion was still in the works, and if he wanted to get it, he really needed to get inside to the banquet as quickly as possible.

"I'm sorry. There just isn't time. I need to get inside right away." He picked up the pace.

"But—"

"Sorry."

Passing photographer after photographer, all of whom tried and failed to get a shot of the fast-moving couple, Sidney shook her head in disbelief. "You know I read the script," Sidney finally said to the hurrying Junior.

"Script to what?" he shot back, almost to the entrance of the hotel.

"*Frankenstein.*"

"Really?"

"Yes, Junior. I do know how to read. And it's pretty obvious to me what this is all about."

Junior's face fell. *Here it comes.*

"A story about a creator disappointed with his creation. Where have I heard that before, Junior? It's a father-and-son story. The father is unhappy with his creation. Could it

be any more obvious what it's about? And why it means so much to you?"

Junior grimaced as they disappeared inside the hotel.

Junior hurriedly led her through the lobby and on into the Embassy ballroom. The event was in full swing, and they entered from the back of the packed ballroom. In the dim light, they maneuvered through a maze of crowded dinner tables. As it always was when it came to these types of celebrations—and no less improbable than the Christmas truce in the Sorbonne—each table was packed with the top brass of a rival studio. Paramount, MGM, RKO, Fox, and Warner Brothers naturally had the best tables, with the smaller studios—Columbia, United Artists, and several others—farther back. All of them were arranged in a giant U-shape and faced a raised dais. In the center of the U was an open dance floor where, under a lone spotlight, a performer played a tinny rendition of "Tiptoe through the Tulips" on a ukulele to the gathered guests. The old man had chosen this portion of the evening's entertainment, and it took all Junior's strength not to throw up from the saccharine performance.

After passing a bandstand filled with idle musicians, they reached the dais, and Junior helped Sidney up onto the raised platform. There were about twenty people, all seated on one side of a long table with a lectern in the middle. His father sat in the seat closest to the lectern, completely enthralled by the performance. Next to him were two empty seats. Junior

led Sidney over, passing a woman in the last occupied seat, who looked up at them, surprised.

"Nice of you to show up, Junior," Rosabelle Laemmle, Junior's sister, said to them as they passed. She was in her late twenties, well put together and stout, and she was dressed quite pleasantly in a black-and-white gown that would have been more at home on a librarian having a night out on the town than on a guest at a Hollywood affair.

"Business always comes first," Junior shot back. He then exchanged forced pleasantries with a rather stern-looking man seated next to Rosabelle—her husband, Stanley Bergerman. After Stanley married Rosabelle a couple years earlier, he was immediately brought into the family business and was currently in charge of keeping the production of two-reelers humming along at the studio. Encouraged by Rosabelle, he shared one common trait with all of the other executives under Junior: he thought he could run the studio better than Junior.

Junior gave them both another quick look-over. "You know, it's the darnedest thing. I could have sworn that on the original seating chart, you were both seated farther down the dais."

"You know how Dad is. Sometimes it takes a while for him to come to his senses," Rosabelle shot back.

"Or maybe you showed up early and rearranged the seating."

Rosabelle rolled her eyes. "You've got quite a knack for fiction. Have you thought about getting into pictures?"

Sidney moved to take the seat next to Rosabelle, which would leave the one next to his father open for Junior, but Junior stopped her.

"Uh-uh. I like you too much." Junior then ushered her over one seat, to the one right next to his father. He then leaned down and whispered into her ear, "I have to take care of something. I'll be right back."

"Of course you do," she answered, without bothering to look up at him.

The old man finally noticed Junior and gave him a nod, but before he could inquire why Junior was late or why he had still not sat down, he spotted Sidney sitting next to him. "Hello," he said, giving her a bright, cheerful smile and clearly enjoying her presence.

Perfect, Junior thought. Just as he'd hoped. His father might be sixty, but he was still a man—and a pretty girl was a pretty girl. With the old man's attention on Sidney, Junior hurried away.

Once off the dais, he headed for the kitchen, passing first through a small hallway, where a gaggle of about twenty dancers in colorful chorus-line costumes waited their turn to perform. With them was a nervous choreographer, who was going over things one last time. Seeing Junior, he was all smiles. "We're all set, boss. Nothing to worry about here. It's going to be incredible."

"That's what I'm counting on," Junior answered without breaking stride. He continued into the kitchen, where it was chaos, as waiters and waitresses hurried about with

plates and trays. Junior quickly moved through them, dodging and weaving, until he came to a giant cake.

"Did I get it right?" a nearby dessert chef said, nodding in the direction of the cake while busily putting whipped cream on a cookie sheet's worth of éclairs.

"You were perfect," Junior said as he grabbed a butter knife. "If only it were that simple." The white lettering on the massive chocolate cake read, "Happy 25th Anniversary. Carl Laemmle, President. Carl Laemmle Jr., Vice President." Junior stared at the final four words: "Carl Laemmle Jr., Vice President." This was how Junior had planned to make his promotion first known. Just a little tease to the town. Then, come Monday, when the newsreel hit the theatres, the story would explode. That's how you do it. The modern way.

Junior sighed. His plan now in tatters, he used the butter knife to completely cover over the words "Vice President" with some of the chocolate icing.

Stepping out of the kitchen, he saw the last of the chorus girls emptying out of the hallway and into the ballroom. It was show time; they were on. Junior quickly crossed the hallway and peered through the door.

The lights in the ballroom suddenly cut out, and the room was swallowed in darkness. The band came to life and tore into some hot jazz. With thumping rhythms pumping through the ballroom, a slice of light hit the dance floor, revealing the gang of dancers. They began an intricate routine, half chorus line and half sex. Spinning and swirling and prancing, they were a giant, undulating mass of legs and breasts and asses.

Junior watched, feeling the intense energy in the room.

Then the swirling cloud of movement broke up, and the girls fell into a classic kick line, their legs locking together in a precision that would have made Busby Berkeley proud. Suddenly, the first girl in the line ripped off a part of her top, exposing a giant letter *U*. And then, like a zipper, girl after girl followed suit, revealing letter after letter until it spelled out "Universal Pictures."

The room erupted in applause. Junior beamed.

The chorus line broke up, and the girls returned to their menagerie of moving limbs—except, unnoticed by almost everyone, five girls broke away and headed toward Junior. Junior quickly moved aside, letting the dancers back into the hallway, where he watched one of them slip into a well-made cardboard mock-up of a biplane, while the other four attached sheets of fabric to the rear waists of their costumes.

On the dance floor, the remaining twenty girls moved to the center, forming a tight pack. Half of them climbed atop the shoulders of the other half and, reaching out, created a giant ball. Then, in unison, they all spun on their heels to show their backs to the party guests, the seemingly abstract patterns on their dresses coming together like a jigsaw puzzle to create a giant globe.

Next to Junior, the five girls slipped past, heading back out to the dance floor. As the last one passed, a thought hit Junior like an express train, and he stopped her. "Unfortunately, I'm not going to mean this the way you're going to take it," he said as he reached down, grabbed the girl's rear end, and ripped out her fabric tail. "Go. Go," he encouraged her, and she ran off to join the others.

On the dance floor, the girls began to spin, like a globe, and just at the right moment, they were joined by the dancer wearing the mock-up of the biplane. She passed right in front of the globe, appearing to fly across it, re-creating the famous logo that appeared at the beginning of each and every movie made by Universal Pictures.

The room erupted with more cheers.

Coming right behind the biplane were the other four girls, whose fabric tails trailed behind like the writing of a skywriter, spelling out "Carl Laemmle, President, and Carl Laemmle Jr."—except the last girl, the one at the very end, had no tail.

Junior looked down at the tail in his hands that he had removed from her just moments earlier. Written across the shimmering satin fabric were the words "Vice President." He sighed; it would have been so great, but the tail had to go. It would have been a disaster if his father had seen it. Since his promotion was still under consideration, the old man would have felt cornered, and Junior was not going to give him that excuse to say no, to deny him his well-earned vice presidency.

Round and round the biplane orbited the globe as the rollicking cheers grew louder and louder.

Junior tossed away the fabric and, in the midst of the building crescendo, sneaked back into the room and up onto the dais.

Faster and faster the dancers went, egged on by the quickening rhythm of the music and the insanely energetic clapping and cheering of the crowd. Then, at the very moment when it looked like they could not possibly go any faster, the spotlights cut out, and all sound disappeared.

Silence. Darkness.

The entire hall erupted into a thunderous ovation. Slowly, the lights were brought back up, revealing Junior standing behind his seated father. As the dancers scampered off, the focus of the ovation switched to the old man, with Junior enthusiastically leading the applause. Junior leaned down and said into his father's ear, "Congratulations, Pop."

Grinning ear to ear, Carl rose and stood behind the podium, eliciting another rise in the ovation. "Please, please," Carl said, playfully tamping down the crowd with his hands. "Please. Come now. Please."

The applause died off, everyone sat back down, and Junior retook his seat next to Sidney.

Carl turned to him with a warm, fatherly smile. "Thank you, Junior. That was wonderful. Wonderful." He then turned back to the rest of the room. "But I still would have put a dog in it." The room erupted with laughter.

The smile on Junior's face vanished as he sank in his chair. But then, realizing everyone could see him, he forced out a laugh, followed by a fake smile.

"It is all hard to believe, but here we all are, twenty-five years later!" Carl said, bringing about another round of applause. "When I think about how it all started . . . " Carl then began telling the story of Universal Pictures, from the beginning.

A few sentences in, Junior stopped hearing the words. He seethed, his father's blow still ringing through his ears. Should he have been surprised? Wasn't this exactly how it had been for the last three years since he was put in charge?

Anything new, anything designed to move them forward, to move Universal to the next level, to make them one of the important studios in town would be dismissed and put down. *Well, I will not let it stop me!*

More applause and more laughter flowed from the crowd as Carl worked the room like a veteran of these types of events, which he was.

"And then it came time to come up with a name for the new company. I look out the window . . . "

Junior listened; what was it going to be this time? A bread truck? A plumber? Maybe a clothier? Junior had heard all three over the years.

"And what should drive by but a Universal Exports truck, and I thought, now that's a name!"

The room erupted in applause. Junior, his face still firmly locked in a rictus, burned inside. What were they all applauding? The moment the name was born? *Who cares? Instead of celebrating what had happened twenty-five years in the past, we should be talking about the things they'll be celebrating twenty-five years in the future!*

Silents were gone. Talkies had arrived. The movies had arrived. Whether the old man accepted it or not, that was the way it had to be—if they wanted to thrive. That was why they had to make films like *Frankenstein*! Great, powerful, thrilling movies. And they had to search out new talents, great talents, talents like James Whale. Those who weren't locked in the past. Who understood what movies were becoming. Who understood—

Junior stiffened in his seat. *Whale?*

Yes, Whale understood. But hadn't he just lost Whale? Hadn't he just let him go for the sake of expediency? Decided to let someone else come in and direct *Frankenstein*? Someone who had made silents? Someone who was firmly rooted in the past? All for the sake of hitting a start date?

Now, even Junior's fake smile faded away. "My God, I've made a terrible mistake," he said out loud to himself.

"What was that?" Sidney asked, leaning in closer.

"Nothing. Nothing," he reassured her. It worked, and Sidney went back to listening to the old man prattle on—he was up to retelling the story of opening day of the studio out here in California in 1915.

Junior hung his head. He had fallen into his father's trap, his father's way of thinking. It could only be one way or the other. Expediency or the future. That was how it was done in the past. Well, he was going to show his father that he was wrong. Dead wrong. His father would see a well-run studio *and* one that fully embraced the future.

Junior's smile slowly returned. Maybe it wasn't too late. If he acted quickly, maybe he could fix things. Junior turned to Sidney. "I need you to do a favor for me."

"And I need you to tell me what the favor is before I agree," Sidney shot back, her eyes skeptical.

"I need you to go on being your charming self. Extra charming for the next couple of hours."

"Okay. That's easy enough. But why?"

Junior began to rise. "Because I have to leave for a little while, and I want you to continue keeping my father entertained."

Sidney grabbed his arm before he could step away. "Where are you going?"

Junior crouched, trying not to draw attention to them. "It's just a small thing I have to take care of."

"Another small thing?"

"Well . . . yes."

Junior tried to get away, but Sidney kept her grip tight. "What is going on, Junior? Why is this film making you so crazy?"

"Oh, come on, Sid. Why do I have to keep repeating this? You know how it works. Things always get a little nuts right before a shoot." He motioned toward his father, who was still completely engaged in his retelling of the company's history. "Just make sure he keeps having a good time, and I'll be right back."

Sidney shook her head. "You better be. Or if you're not, it better be because you're working on my next film."

Junior laughed. "Deal." He hurried away.

A flurry of phone calls from the hotel lobby got him nowhere: Whale's butler said he hadn't returned home yet from the studio, and everyone else he could think of who knew Whale was clueless. Whale was a bit of a mystery, his true self kept hidden beneath a well-polished veneer of English detachment, but Junior was also aware of some of the rumors that surrounded him. Perhaps this was the course to pursue.

In the back parking lot, Clancy was seated in the front of the limo, having a smoke. Seeing Junior's hurried approach, he quickly threw away the cigarette and immediately stepped out and opened the back door for Junior.

But Junior didn't get in; instead, he stopped directly in front of him. "Clancy, you used to drive for Valentino, correct?"

"Yes, sir. Many years ago," Clancy answered, not quite sure why he was being asked.

"Were there any clubs that a person of his . . . persuasion might go to if they needed to lift their spirits?"

Clancy tilted his head back, understanding. "I'm afraid those stories were not true. I can assure you that he was quite interested in the ladies."

"Oh." Junior puffed his cheeks and exhaled, disappointed.

"However, I did drive for William Haines for a time. I think I can help you out."

At the first place they tried, a small, unmarked bar off Melrose, he didn't find James Whale, but he did find confirmation of a rumor that had been bandied about at many a dinner party about one of Fox's most popular leading men. At a second place, again, no James Whale, but he did see proof that a certain paternity suit, which had been all the rage in the papers, was going to be a bust.

It wasn't until the fifth place he tried that he hit pay dirt. Though he had never been there before, Jimmy's Backyard

was a well-known pansy joint to Junior and the rest of Hollywood. Moving from room to room in the cramped and smoky converted home, he spotted two of Universal's leading men. Both looked mortified at the sight of Junior invading this secret world, but then their expressions changed to that of intrigue. Junior quickly looked away. Their sexuality was old news to him, and he could not have cared less—if you made the studio money while inside their walls, then who cares what you did when you were outside of them?

He finally found Whale, seated with David Lewis, a well-known producer at Paramount. Their close quarters to each other, in spite of there being plenty of open space, proved that Junior's hunch had been right: clearly they were a couple. Lewis appeared to be having fun, talking with a bevy of high-spirited folks all around them, but Whale looked miserable, like a church lady dragged to a boxing match. When Junior walked up to him, he nearly fell back out of his seat.

"Junior!" Whale said, catching the attention of the others.

As everyone looked on, astonished, Junior sat down a few feet from Whale. "Do you know what I remember most from the first time we talked?"

Not sure where this was going, Whale shook his head. "No."

"You had just come to America, and you were doing the rounds of all the studios. We spent a good half hour in my office, and not once—not once—did you mention any of your previous work. All you talked about was what you

wanted to do—the films you wanted to make, the stories you wanted to tell. At that moment, I knew I had to get you to Universal. And I did."

A waiter came by and asked Junior if he wanted anything to drink, but Junior waved him off and returned his attention to Whale.

"Just because we both believe in the future doesn't mean we have to have the same way of getting there. I have my way, and you have your way. Which means I have to apologize to you for taking your way away from you."

Whale nodded noncommittally. "Thank you for the apology," he offered flatly.

Pleased that he had Whale's attention, Junior pulled his chair closer and leaned in. "But most importantly, I think I know how to give it back to you."

Two days until the first day of filming on *Frankenstein*

"Cut!"

The word echoed loudly throughout the cavernous soundstage, and the entire cast and crew of Columbia Pictures' production of *The Guilty Generation* froze where they were. They had just completed a complicated shot involving several pages of dialogue that featured Mob leader Tony Ricca, played by Boris, excoriating his various henchmen, whom he had assembled in his office, for not doing better in the gang war they were fighting. All eyes turned to the film's director, Rowland Lee, as they searched his face for his reaction to what had just transpired. Rowland was a short man, barely taller than the camera he stood next to, with a kind face that still seemed almost apple-cheeked, even though he was almost forty. Chewing the end of a pipe that was forever balanced in his mouth, whether lit or not, he mulled over what he had just seen. Unconsciously, Boris took a quiet step forward, as if pushing him to come to a decision.

Rowland finally pulled the pipe from his mouth and smiled. "Print it, and let's move on to the next scene!"

Boris sighed, relieved. Everyone else let out a small cheer, and then the entire studio erupted into action, with stagehands, camera crew, lighting technicians, costumers, makeup artists, and everyone else on hand for the day's shooting hurrying to prepare for the next scene. Boris, with the rest of the cast, headed over to a row of canvas chairs. Passing Rowland, who was busy conferring with his cameraman, Boris looked in his direction. Rowland noticed and returned the gaze with a reassuring nod.

Pleased, Boris continued on until he reached an unoccupied chair and collapsed into it. He closed his eyes and said a silent prayer in the hope that they could get through the next shot just as quickly as this one. For years, Boris had wished that one of those lightning bolts of good fortune would finally crash down from the heavens and hit him, and in spite of the unpleasantness with his agent the night before, it might finally have happened. He had arrived early on set, at 5:00 a.m.—a full hour before call time—in the hope that he could get a moment alone with Rowland to plead his case about the need to be released from this picture as soon as possible so he could begin work on *Frankenstein*, first thing Monday morning.

Boris and Rowland had gotten on quite well from the start of the shoot, but where divine intervention, or just dumb luck, had come into play was when Boris discovered that Rowland had started his career as an actor on the stage. And not just as an actor but as a member of a family

of actors who had, like Boris, spent years just barely eking out an existence, doing stock company productions in small towns in the middle of nowhere. It took very little explaining for Rowland to understand what the opportunity meant to Boris and how it could truly transform his life. Rowland had agreed that he would do what he could to try to get all of Boris's scenes shot by the end of the weekend.

True to his word, things were moving quickly. The last scene had gone well—no one flubbed their lines, and no one missed their cues. It was going to be close, but if this continued, there was a really good chance Boris would be done in time.

"Everyone! If I could get everyone's attention!"

Boris opened his eyes to see Rowland had been joined at the camera by a rotund man, who appeared to slump, seeming defeated, with his eyes firmly aimed at his shoelaces and a pair of headphones hung around his drooping neck. "I need everyone's attention," Rowland continued.

The work in the studio came to a sudden stop.

"Apparently, we've had a problem with the sound recording and . . . " Rowland sighed. "We're going to have to do that scene again."

There was a noticeable gasp in the studio.

"How much of it?" a nearby script girl asked carefully as she rifled through her copy of the script.

"All of it."

Another gasp. Everyone stood motionless, stunned.

"You heard him!" the assistant director intoned loudly and then clapped. "Quickly now—let's reset for the last shot."

Everyone quickly went back to work, but in spite of the admonishments, the crew went about its work with more than a slight air of defeat. Boris closed his eyes again, but this time there was no prayer. What was the point? He sank down in his chair, beaten. It was over. They would never be done in time. He was stuck on this job for several more days—well into the next week and well past when he was needed on *Frankenstein*.

His mouth began to hurt. It was his teeth, in the very spot where his bridge was. The bridge he wore was a constant reminder of the price he had paid for this life as an actor. Many years earlier, while on tour with some long-forgotten show, being performed in some long-forgotten town, his teeth had begun to hurt. But there was no money to do anything about it. At least not and still afford to eat. So he had let his stomach make the choice for as long as he could stand the pain, before finally giving in and paying to see a dentist. But by then, it was too late, and several rotted teeth had to go, replaced by a hastily put-together dental bridge.

And now it was throbbing, almost as bad as it had been before the decayed teeth were finally pulled. Fighting back the pain, Boris opened his eyes, and his gaze caught Rowland's. The two men locked eyes in the way that only two men who had both shared the same ups and downs of the life of a struggling, nomadic actor could. The uncertainty, the starvation, the longing for just a bit of lasting success, combined with the dream that, in spite of all the misery, if one truly worked hard, he would come out on top.

Rowland was the first to break away. "Hold on a moment!" he yelled out, again bringing the studio to a standstill. "I have another idea."

Two hours later, Boris parked in his garage and threw the car door open. Not only was he done for the day, but he was also done for the entire shoot. Hitting the cement, he hurried out of the garage and, leaping up the first three steps in one bound, began the long climb up the stairs to his apartment. Today the climb felt short, as he continued taking two or three steps at a time. *God bless Rowland Lee*, reverberated in Boris's mind as he ascended higher and higher.

Rowland had decided to reshoot the flubbed scene with just Boris sitting at a desk, issuing orders to his henchman over the phone, instead of a half dozen actors and several cameras going at once—not to mention the wild choreography of mic movements needed to catch all the dialogue split between the assembled cast members.

It had gone perfectly, done in only one take.

Rowland was so pleased with the approach, not to mention how happy he had made the film's producer, that he decided to shoot the rest of Boris's scenes this way. An hour and a half later, Boris was headed to his car in the studio parking lot, done for the day and the entire picture.

He was going to be the Monster in *Frankenstein*!

Halfway up the stairs, Boris slowed, eyeing what looked like a package another ten or so steps in front of him.

Reaching it, he bent down and picked up a large envelope embossed with a large Universal Pictures logo. Clearly, a studio courier had started up the stairs, gotten winded, and decided that this was close enough to the apartment and dropped the envelope. Boris opened it; the script to *Frankenstein* spilled out.

They sent someone out special, just to deliver it to me! Boris thought, delighted.

He studied the first page. Beneath the title, *Frankenstein*, was the date—8/16/31. Boris had read an earlier draft during his makeup tests, but this was clearly the latest draft. He flipped through it; everything he read seemed familiar, but this time, the words "the Monster" leapt out at him. After the first twenty or so pages, it was everywhere. Scene after scene after scene of the Monster rampaging, attacking, being chased, and, finally, being cornered in a windmill.

Just fantastic! Boris thought. This was truly no small part, not some subsidiary character who shared a couple of lines with Edward G. Robinson in one scene or brought Gloria Swanson a cup of coffee in another. No. The Monster was who the movie was about. This was the real deal. Six weeks on one movie. The most he'd ever had was two weeks, and that was only once.

Boris closed the script and clutched it tightly. This was it. This was his chance. Focused, he marched up the remaining steps, his mind replaying the conversations he'd had with James Whale, the film's director, before the role had been taken away from Boris. They had discussed making the Monster more than just a brute and instead portraying

him as an outsider, confused, maybe even sympathetic at times—something they could both relate to, as they were both from England and visitors here in the strange land called Hollywood, and their own experiences in this adopted homeland, at times, ran the same gamut.

But Boris wanted to go deeper, and damn it, he would. He would find something more, something—dare he say it?—profound. Brimming with determination and champing at the bit to get to work analyzing the script, he pushed open the front door of his apartment.

"*Surprise!*" The shouted word came hard and fast at Boris, almost knocking him back down the stairs, yelled at him from a crowd of at least thirty.

Confused, Boris searched the throng that was tightly squeezed into his cozy apartment before finally spotting Dorothy among the cheering pack.

She gave him a shy smile. "I'm sorry, Boris. I was so happy for you that I called a few people and, well . . . "

Boris shook his head, not sure what to make of things. This was his big moment, his big chance, and he really wanted to get to work on the script. But he could see the overjoyed look on Dorothy's face. Yes, she was throwing the party for him, but he knew she wanted it too. She wanted everyone to know that both of their lives were about to change. Slowly, a soft smile floated over his face. "Well, this is certainly not necessary—but now that we're all here, why don't we have some fun?"

A loud cheer rose up from his assembled friends. Somewhere in the background, a radio was turned up, playing

some hot jazz. Corks were popped, bootleg booze was poured, and the party was on. Boris moved through the jovial crowd of friends and acquaintances, peppered with pats on the back and congratulations. He'd been to more of these types of parties than he could remember since arriving in Hollywood. It was a tradition among his circle of up-and-coming actors and actresses whenever someone in their orbit, still fighting to make it, finally got their big break; there was always some sort of celebration.

But Boris was still focused on getting on with his work. He hurried through the throng, taking in the congratulations and giving Dorothy a heartfelt hug, hoping that when the party inevitably broke up into different cliques, he could slip away, unnoticed.

However, today was very different. He'd never been the center of attention at one of these parties, so no one would leave him alone. Whenever anyone laid eyes on him, they encouraged him to come join them so they could bathe him in praise.

Determined, he searched for some quiet. Leaving the packed living room, he stepped into the hallway and tried the first door—the bathroom. But when he opened it, he was greeted by a jovial man with a fleshy face, who Boris kind of remembered from a couple of days on a cheapie down on Poverty Row, and two tipsy girls who still sported Louise Brooks bangs. They greeted him heartily, raising their filled cups to him in a toast, begging him to join them in some great bathtub gin. Boris thanked them and backed out of the tiny room.

He hurried on through the hallway to his bedroom, dodging a couple of chorus girls who congratulated him and implored him to join the kick line they were practicing with the help of a third, more experienced dancer. He demurred and opened the door to his bedroom, quickly yanking his head back to dodge a lasso thrown in his direction by a fully dressed, ready-for-the-saddle cowboy. After congratulations from the cowboy and his audience of five, who were sprawled on Boris's bed, he hurried away.

But to where? He was trapped in his own home. Moving about the crowded apartment, his mind started to drift back to another crowded party, many years earlier, where he'd also been the center of attention. Though at that one, it was most unwanted.

It was back in '09, and it was the last time he had seen all of his brothers and sisters together in one place. It was for a cousin's wedding, not far from the family home in Enfield in the county of Middlesex, where he'd still lived, though he was closing in on twenty. Even though the Pratt siblings numbered a total of nine, with Boris the youngest, all of them managed to show up for the event. Initially, Boris had been excited at the prospect of having his entire family together in one place, something that had never happened before because of the range of ages, with Boris now being nineteen and his oldest brother in his fifties. But his excitement quickly faded when it became apparent to Boris that, to his family, *he* was the center of attention, not the bride and groom.

Each family member had a different theory of what Boris should do with his life. Several thought he should go

into foreign service, like most of the family, while others thought he should consider a career as a teacher. Even his favorite brother, Michael, the one who had briefly had a career as an actor and had first exposed Boris to the world of performing, had pushed him to consider a job in the world of finance.

Boris hated each and every one of their ideas. And why did he have to choose just one thing to be? It was one of the things that he loved about being an actor—one day, you were a mysterious rajah from the Far East; the next day, an Indian living on the Great Plains; and then the next day, a foppish colonel in the service of Napoleon. There were so many choices, so many things to explore. Why should a person be pinned down to one existence? To one life story?

But his siblings were relentless, and by the end of the party, they had succeeded in one thing—getting Boris to make a choice. He would leave England as soon as he could to pursue a new life on the other side of the Atlantic, away from all of them.

Now, Boris crossed back through the packed living room, receiving another round of pats and well wishes. Heading through the kitchen, he passed three old actor friends who had found steady work in films as full-blooded English gentlemen, in spite of being born and raised in Detroit, Poughkeepsie, and Little Rock, respectively. They saluted Boris's success with a spirited doffing of their bowlers, punctuated with a series of encouragements: "Hear, hear," "Cheerio," and "Top marks, sir." Boris thanked them with a nod and then slipped into a small nook at the end of the

room. Thankfully, with the exception of a phone on the wall and a washbasin that Dorothy used to dutifully do their wash every Sunday, the room was empty. Boris took a deep breath of relief, flipped open his script, reached out to close the small privacy curtain used when any delicates were being soaked, and began to read:

Exterior, long shot. Dusk. The torn, bloody banner of the sky, purple and black shadows that—

The phone rang.

Boris exhaled sharply, almost laughing at the absurdity. Would he ever get a moment's peace?

The phone rang again.

Heavily, Boris reached out and answered it. "Hello?" Hearing the voice on the other end, Boris stiffened instantly. "Yes, this is he."

As Boris listened intently, Dorothy approached, carrying a bottle of champagne with two glasses.

"Yes . . . yes . . . ," Boris said, keenly focused on the conversation. "Absolutely. Thank you." He hung up and looked away, gazing through the small window that looked out on the patio, where they often ate their breakfast on warm summer mornings.

Having filled the glasses, Dorothy held one out to Boris. "I know. I know. Never when you're working, but come on—just one."

But he didn't take it, and he didn't answer. Instead, Boris just kept looking away, out the window.

Dorothy prodded him again with the outstretched glass. "Come on, Boris; let's celebrate."

Slowly, Boris turned to face her, his face flat. Or maybe there was some moisture in his eyes. He swallowed. "They want me to do a screen test."

.

With an enthusiastic swipe of his pen, Junior drew a line through the words "Have secretary tell Karloff" from his list. Pleased, he eyed the piece of paper as he sat at a small table in the kitchen of his spacious apartment. There were about a dozen items on the list, and every one of them had been crossed off.

Exhilarated, Junior jumped to his feet, crumpled the paper into a ball, and, with the sleeves of his crimson-and-gold silk robe flapping in the air, did a windup that would have made Walter Johnson proud and threw a strike into a nearby garbage can. The night before, after Whale had accepted Junior's summation of his reticence to the last-minute casting change and agreed to be open-minded and participate in giving Karloff a screen test at the studio that afternoon, Junior had gone about setting it up.

Quietly.

No use in word getting out. Just keep the whole thing under wraps. He enlisted Mary's help in putting everything together. A call from her would bring about far less suspicion than a call from Junior himself, and now everything was set. Sure, there was something a bit pathetic about the head of a studio having to sneak around like this, but it also excited Junior. It reminded him of not that long ago, just

a few years back, when he'd first started producing around the lot. He was just Uncle Carl's teenage son, fooling around with a movie camera. Boys with their toys. Junior even convinced his father to give him a few dollars, sort of an allowance, so he could have a minuscule budget, even by Universal's usual tight standards. But Junior found a way to stretch things; they'd sneaked onto sets after another production had wrapped for the day, and pretended to be one of the A-pictures when borrowing an outfit from the Costume Department. They'd even gone as far as sneaking a light or two off a production truck parked unattended around the studio.

But that was five years ago. So much had changed since then, and so much had not. Even after all the success—the boffo box office, the awards, the innovative films—people still questioned Junior.

And that was why he wanted the promotion to VP so badly.

Junior Laemmle had what was quite possibly the worst curse that could ever be placed on a man. He was the son of a great man. Now, in the rest of the world, being the son of a president or a Supreme Court justice or a great ball player would be an honor, but in this town, Hollywood, it was the mark of Cain. Because in this town, you could be an ex-prostitute, a murderer, a drunkard, a junkie, a pedophile, a cross-dresser—anything—and no one cared. But, if you were the son of a great man in this town, well, you got about as much respect as drunkards and whores and pedophiles got in the rest of the world. It didn't matter what you

did—make a hit out of *Dracula*, make the first million-dollar color production—they just didn't see it. All they saw was the shadow of the great man who stood behind you.

Still buoyed with adrenaline and knowing that the momentary calm would not last, Junior wandered out onto a balcony that was just off the kitchen, sticking out from the side of his building like the petulant tongue of a four-year-old. Besides just wanting desperately to move the hell out of the family mansion in Beverly Glen, Junior had chosen the Chateau Elysee Apartments on Franklin because it was perched at the top of a small hill, providing an incredible view of the ever-expanding expanse of greater Los Angeles. Splayed before him and beginning to shimmer in the rising heat, he could see all the way to MGM and Hal Roach Studios way out to the west, to Poverty Row and Paramount to the distant east, with the rest of the film colony in between.

And this further inspired him in his never-ending battle with his father.

Almost none of what he could see from his balcony had been there when his father first built his studio. Yes, Universal was an incredible accomplishment, but so much more was happening now, and Junior was tired of seeing them being passed over by the other studios. So much of the talent that had built the rest of Hollywood had first started at Universal, only to move on and make fortunes elsewhere. Valentino, Pickford, Ford, and many, many more had been in the employ of Uncle Carl, only to slip away and go elsewhere to build their careers. Even Walt Disney had started

out as an employee of Universal Pictures, only to move on before creating Mickey Mouse. All of it infuriated Junior. The old man just couldn't see the future.

As expected, an energetic knock on the door interrupted the calm. "Huh, they're a little early," Junior mused to himself as he hurriedly exited the kitchen and crossed his spacious, white-carpeted living room. Darting between the handsome furniture, all personally picked by Junior in the latest styles from both here and overseas, Junior made it to the front door just as the knock repeated itself.

"All right, all right. Hold your horses. I'm here," he said as he pulled open the front door—to reveal a young boy of about eleven, dressed in knickers and a rumpled cotton shirt with several unbuttoned buttons, with a driving cap worn backward on his head of unruly hair.

Junior recognized him immediately as Mickey, the nephew of the studio bootlegger. "There you are," Junior said as he stared down at the small boy, who struggled to hold a case of Seagram's whiskey in his skinny arms. Mickey offered it up to him, but instead of taking it, Junior grabbed a small, ornate wooden box that was riding atop the case of whiskey. He quickly examined it and, pleased, started to shut the door. "Thanks."

"But what about this?" Mickey said brightly as he again held out the case for Junior and raised his eyebrows enticingly. "My uncle thought you might need this right about now."

"Well, that would be another thing your uncle got wrong," Junior said, glowering down at him.

"But he was sure."

"Just like he was sure that I was going to be named vice president."

"So, you don't want it?"

"Now you're catching on." Junior eyed something out of view on his side of the door. "But there is something else you can do for me." Junior opened the door farther, and Mickey peeked in, eyeing two other cases of unopened Seagram's whiskey. "You can take these back." Junior grabbed the two cases and, imbued by the disappointment they represented—the post-banquet after-party at his apartment to celebrate his promotion had gone the way of the dodo—placed them on top of the case Mickey was already holding. "Tell your uncle to credit my account."

"Jeez, thanks, Junior," the kid said, struggling with the three cases. "Aren't you going to at least give me a tip?"

Junior didn't know whether to smack the kid or to sign him to a contract before Hal Roach grabbed him for one of his *Our Gang* comedies. "Sure," Junior finally said. Over his shoulder he glimpsed Sidney entering the living room behind him and hurried to close the door. "Never trust anything your boss says."

Junior slammed the door shut and, slipping the wooden box out of sight, turned to see Sidney walking straight toward him. She wore a flowing cotton beach gown dotted with colorful geometric patterns, and with each step, it opened just the right amount to reveal a stylish one-piece chartreuse bathing suit underneath.

"What was that?" she asked as she joined him near the door.

"Just this." Junior pulled the wooden box out from behind his back and held it up for Sidney to see.

She pursed her lips into a cupid heart and tilted her head. "What have you got there, Junior?"

"Open it."

Sidney hungrily grabbed the box and lifted the top off. Inside was a shimmering silver necklace inlaid with an array of colorful jewels. Sidney's eyes lit up. "Junior, how beautiful!" She retrieved the necklace from the box and hurried over to a nearby oval wall mirror. She held it around her neck, admiring how it looked against her smooth skin. "I saw Garbo wear one just like this on the cover of *Modern Screen*."

"Sort of," Junior confirmed as he stepped up from behind and began to fasten the necklace for her. "That was last year's. *This* is this year's. It hasn't even been released yet." Finished, Junior took a step back.

Sidney admired herself in the mirror. "You mean, I have something before Greta Garbo?"

"Yes." While Sidney continued to admire herself, Junior took a breath, bit his lower lip, and averted his eyes. "So, I'm just gonna run to the studio for a bit, and then I'll meet up with you later in Venice at the event." When Junior looked back at Sidney, he was met with an icy stare.

"You can have it back, Junior. I'm not that stupid." Sidney held out the necklace for Junior. "You are literally trying to distract me with a shiny object."

"I'm sorry; something has come up."

"Junior, we had a plan. The WAMPAS Baby Stars is a big event, and you were going to be my escort. Remember? In

Newport? At the beach? You told me we had to look good; there was gonna be a need for pictures of you and me in the next week or two and everybody was gonna be looking for 'em, and you wanted something new out there, something that showed me as the hot new thing."

Junior knew this was true. It was a big event, and yes, he had planned on escorting her there. And he had been looking forward to it. Especially on this weekend.

The Baby WAMPAS was put on by the publicists' guild to celebrate new starlets in the film business. Each studio chose one new actress to represent them at the event, and Universal had chosen Sidney. It was such a perfect setup. The new star on the arm of the man who discovered her, the newly minted vice president of Universal Pictures.

Sadly, it was not to be.

Junior sighed as his whole body sank. "You're right," he finally admitted. "I should have just come out and asked you if you would go there without me and represent the studio."

What he had done wasn't very modern, wasn't very forward-thinking, and he knew it. Junior straightened up and looked her straight in the eye. "Will you go there and represent the studio?"

Sidney looked at him closely. Junior could tell she was trying to decide if he was playing her again. Truth was, Junior himself didn't know, but he did know he would do whatever he could to get her to go. It would not look good if Universal didn't have a representative at the WAMPAS Baby Stars event.

"Why can't you take me?"

"Like I said, something's come up."

"It's *Frankenstein*, isn't it?"

"Something came up."

"It is!" Sidney threw her hands in the air. "What is it about this movie, Junior? We have a deal. We're supposed to be all about having fun, some laughs, and being together as long as we're having a good time. Well, I'm starting to not have a good time." Sidney thrust a finger in his direction. "I need to work, Junior, and you need to get your act together."

"Who says I don't?"

"Then tell me what is going on!"

"I can't do that."

Sidney folded her arms across her chest. "You know what? I don't care. Unless it has to do with my next picture, I'm not interested."

Junior saw an opening and quickly stepped through. He raised a knowing eyebrow, making sure Sidney noticed.

She cocked her head coyly. "Does it have to do with my next picture?"

"I can't tell you that."

Sidney burned a look in his direction. "Junior!"

"On the other hand, I can't tell you that it doesn't."

Sidney eyed him again. "All right, Junior. You better not be jerking me around."

He held up two fingers on his right hand. "Scout's honor. Everything is gonna work out just right."

"It better." Sidney gave out a long, acquiescing sigh but shook her head in disgust. "So you want me to go to this thing alone?"

Before Junior could answer, there was a knock at the door. "Not exactly," Junior answered with a grin.

As Sidney eyed him suspiciously, Junior stepped over to the front door, opened it, and ushered in the two heavy-set writers who had been pitching Junior the day before. "Sidney, I'd like you to meet Bob and Tom."

They were both dressed in what clearly were the best suits they owned but which were at least five years out of date and hopelessly wrinkled. They each had combed their hair like men who rarely did. With their hats clutched firmly in their shaky hands, they both stepped forward and said eagerly, one after the other:

"Nice to meet you."

"Honored."

"I don't want to meet you," Sidney shot back at them and then turned to Junior. "You want me to go with these two clowns?"

"Clowns?" Junior said emphatically. "These are two fine writers who, just yesterday, pitched me a fine story that I am very interested in."

Sidney raised a piqued eyebrow. "Oh, yeah? Something that might be good for an actress currently looking for her next project?"

Junior turned coyly away. "You never know."

Sidney took a playful step toward Junior. "Because that would make me very happy."

"What did I tell you?" Junior said, no less playfully. "Everything is going to work out just fine." He took a step toward her.

Their faces were just inches apart. "Well, that would be just fine," Sidney said brightly. "Because sometimes I don't half hate you."

Junior smiled. "That's good to know."

They kissed, and their lips interlocked for a few seconds. Bob and Tom turned away, unsure of what to do. Sidney finally pulled away, just as the kiss was changing from playful to passionate.

"And we're still going together to the premiere tonight, as planned?"

"Of course." Junior nodded emphatically.

Sidney took it in and then gave Junior a big wink. "Then I will see you then." She turned to Bob and Tom. "Come on, boys, let's hit the road. We've got some work to do." She headed for the door.

Bob and Tom turned to Junior before following. "Thanks for calling us, Junior," Bob said, clearly pleased.

"Thanks for coming on such short notice," Junior offered.

"Thank you, Junior. We were so excited that you became interested in our story," Tom said, fighting how happy he really was.

"Well, I think—" Junior paused, searching his mind for something.

"*Hearts on Broadway.*"

"Right, right. *Hearts on Broadway* has some real potential." Junior tilted his head in the direction of the door and the just-exiting Sidney. "Take good care of her."

Bob and Tom spoke simultaneously, saying, "You can count on us" and "We will," and then headed out after her.

Junior watched the door shut before quickly turning and hurrying toward his bedroom to get dressed. There was much to do.

........

Bela jumped up in bed as the sudden blast of sunlight splashed across his face. As the fog in his mind dissipated and his bleary eyes cleared up, the sight of Morlan moving about, opening the shades, came into focus. He was in his bedroom, and it was morning. Or late morning, as his eyes finally unclouded enough to read the small clock on his night table—11:17 to be exact.

He opened his mouth to speak; his throat was dry and harsh. "Did anyone call?" Bela rasped.

"No, sir."

"Are you certain?"

"Quite."

Bela finally accepted the answer with a curt nod. Not that he would admit it, but he was a bit surprised. He was certain Junior would try to reach him again in the morning, especially after Bela had been gone when he showed up at his house the day before. But apparently not. So be it. It wasn't like his feelings on being in *Frankenstein* had changed. He still didn't want the role of that stumbling buffoon.

As he swallowed to moisten his aching throat, an intense throbbing in his head arrived, and the events of the night before came rushing back. After the abrupt departure of Robert Florey from their dinner, Bela had gone over to a

friend's house, Dr. Emil Korky. He was a part of the vibrant Hungarian colony in Hollywood, as was Bela. Informally rotating among a half dozen or so homes of the most prominent Hungarians living in Los Angeles, every weekend there was at least one gathering that seemingly consisted of every actor, actress, writer, and director who was originally from Hungary but had now immigrated to Hollywood.

Bela loved these gatherings. He loved being among his countrymen, speaking their native Hungarian, and catching up on the latest news from their beloved homeland. And it was the one time he got to eat *palacsinta* that tasted just right. Not too sweet, like the Americanized version that was served in the various "Hungarian" restaurants in town.

Bela also reveled in the attention he received at these gatherings. As they were all originally from Hungary and all artists, everyone remembered seeing Bela onstage. He had been quite well known in Budapest, twenty years earlier, before the terrible war that had transformed all of their lives, and everyone in this crowd knew him as a star of the national theatre. Back then, he had been known as Bela Blaskó—quite the young man of Budapest, caught up in one delicious scandal after the next, tales of which were numerous and all greatly exaggerated, often by Bela himself, with whispers of passionate lovers and vengeful duels.

The night before, after the strangeness of his dinner with Florey, he particularly needed the attention. And that's where the evening took another unexpected turn. As was often the custom at these events, there was a special guest at the party—sometimes it was a young relative of one of the

guests, visiting from Hungary, or maybe a grandparent, or sometimes even a government official.

And in this case, it was an arts ambassador, Miloz Kelnig, a distinguished man, who appeared to be the same age as Bela. Typically, if the guest was a woman, the initial small talk would be about where you grew up, where you went to school, and so on. But if it was a man, especially of a certain age, inevitably the talk got around to your service during the war. Once through the generalities of where they served and when they got out, the conversation would move on to other things. But in this case, Bela and Ambassador Kelnig had a lot in common. In fact, after working their way through their years of service, branch of service, and army unit, they discovered they had served in the same corps. And that's when the conversation came to a halt.

They had both served in the Fifth Corps. It was a large group, with hundreds of men, so Bela and the ambassador didn't remember meeting before. Nonetheless, they did share a bond—or more precisely, a scar. In war, one always hopes that one's group will be famous for its valor or a victorious battle that is won, but this group was not.

It was famous for one incident.

An incident that was merely a story to the ambassador, but to Bela, it was something he had lived. It was in the winter of 1916, the second year of the war, and Bela's unit had become a ski patrol, serving in the Carpathian Mountains on the Eastern Front. During the ebb and flow of battle, there was always downtime. During these periods, the vast

majority of the men would stay hunkered down in their trenches, trying to stay warm. But each day, a patrol was required to go out and do reconnaissance of the area, checking for any advancing enemy troops. Twelve men were randomly selected for this duty. Usually, they would be gone for a number of hours, and then they would return and inform the commanding officer of what, if anything, they had observed. It was winter; weather had hampered most military operations, so three weeks of patrols had passed with little of interest occurring.

Then one day, the patrol didn't return.

It wasn't uncommon for them to be late or even to straggle in after dark. But the next morning, when not a single soul had returned, it was clear something had happened.

Another patrol, a search party, was put together to go and find out, and Bela was one of the twelve selected for this duty. They searched for hours, finding nothing, until they reached the farthest boundary of the patrol area.

And that's where they found a massive ditch, at least forty meters deep and a hundred meters wide, clearly caused by an enormous explosion.

The spot was well known by the patrols because there was an abandoned petrol truck on the spot, its massive tank still full of gas, that had broken down weeks earlier; in the inclement weather, no one had been able to come get it. The soldiers would stop here, siphon a couple of gallons out of the tank, and then, using a metal barrel from another abandoned vehicle, would warm up for about fifteen minutes before making the trip back to where they were based.

It didn't take long for Bela and the rest of the men in the search party to figure out that while the patrol was warming themselves, an errant shell had hit the petrol truck, unleashing a massive explosion and instantly killing all twelve of them. But it was what was left of them that was most distressing.

Nothing.

Not a cap, not a sock, not a shred of skin or bone, not even a gun. They were gone. All twelve of them. Vaporized. Wiped from the face of the earth as if they had never existed at all.

Bela and the ambassador had quickly moved on to other topics, but the memory lingered with him for the rest of the evening. When the traditional late-evening *pálinka* brandy was brought out, Bela was the first to ask for a second glass. And then a third, a fourth, and a fifth. From there, he lost track.

The phone rang in another room, the stinging sound aggravating his throbbing head. After a second ring, Morlan answered it, the murmur of his conversation floating toward Bela. Bela smiled. *It must be Junior. But it doesn't matter. I am still not interested.* But he couldn't help himself and leaned forward, trying to make out what was being said. It was to no avail, and when the murmuring ended, Bela sat back on the bed, adjusting the pillows as he waited for Morlan to hurry in with the message.

A few moments passed before Morlan entered, carrying a breakfast tray and a folded morning paper. Bela eyed him closely, but Morlan was all business and placed the tray on

the bed next to Bela. He snapped open the newspaper and, headline first, placed it next to the tray. "Enjoy, sir." Morlan turned and headed for the door.

With a hint of disappointment, Bela watched him go. Finally, Bela called after him. "Morlan, who called just a moment ago?"

Morlan spun around on his heels. "Oh, that was Mr. Kelts. The owner of the Orpheum Theatre downtown who keeps trying to get you to appear at his theatre with a screening of *Dracula*."

"Oh, yes, I remember him," Bela said, nodding as the memory came back. "But that was months ago."

"Yes. But as he likes to remind me whenever he calls, the film is quite popular, so he's been quite persistent. The screening happens to be this afternoon, and he thought he would give it one last try. I told him you weren't interested." Morlan spun back around and left the room.

Bela watched him go, anger slowly rising in him. Ah, at least someone wants to see what Bela looks like! Not covered in pounds of makeup! Not stumbling around like an oafish mute. But talking! Acting! Bela poked at his food but found nothing of interest. More out of habit than hunger, he grabbed a piece of toast and moved it toward his mouth. But just before it reached his lips, Bela stopped.

I am loved, wanted, respected in other places! Universal needs to know this. I have scores and scores of fans, and they need a little reminder of this! They must see it for themselves!

Bela dropped the toast, pushed the tray aside, ripped back the bedcover, and leapt out of bed. "Morlan, get my cape!"

........

With Clancy driving Sidney and her two escorts out to Newport Beach for the WAMPAS Baby Stars event, Junior drove himself to the studio. On his way to the main gate, he passed a row of billboards that lined the wall outside the studio. In an explosion of eye-catching words and colors, they brightly advertised the studio's latest films. Junior smiled, proud of the studio's current product, and his grin grew quite wider at the thought of the billboard for *Frankenstein* joining them.

Reaching the main gate, Junior began to turn, when suddenly he spotted a familiar car parked up ahead in front of the executive building.

It was his father's limo.

A sense of dread washed over him. His father was at the studio. Now. A mere couple of hours before they were scheduled to shoot the test with Karloff. This was not good. Junior continued past his turn and instead pulled into the roundabout in front of the executive building. Junior was out the driver's side door a split second after the car had come to a complete stop.

Racing inside, he rushed through the halls. Being Saturday, the building was mostly deserted, and his clattering feet went unnoticed, save for a few scattered members of the cleaning staff. Junior hurried through each department—Production, Publicity, Casting, Employees; they were all empty. He even tried his own office, but it too was empty.

"Darn it," he said as he kicked the ground. Where was his father, and more importantly, why was he back at the studio today? Yesterday, he had walked around the studio before the banquet to check things out, so there really was no reason to return today.

Junior suddenly turned white.

Unless he somehow found out about the screen test. But how? It wasn't possible. Junior had covered all his tracks and told as few people as possible, and none of them had any contact with his father. Still, the thought sent Junior into a panic. He rushed out of the building and hurried across the lot. Again, being the weekend, there was very little activity, and he made it quickly over to Stage 6, where they planned to shoot the screen test. But when he arrived, it was deserted. The skeleton crew that Junior had handpicked to cause the least amount of attention was not due to arrive for at least another hour.

Stymied, Junior briskly wandered, searching. Writers' bungalows, dressing rooms, props, sets, Wardrobe, Editorial—he even checked a stretch of buildings that the family had lived in when visiting the studio before making the permanent move west and buying their own place. No sign of his father.

Additionally, nothing seemed out of order. Just a quiet Saturday at the studio. The calm before the storm that came every Monday morning when the studio would burst back to life, and dozens of productions would, in earnest, get back to the business of making movies. And this Monday, it would happen to include the very first day of production on

Frankenstein. With this thought, Junior picked up the pace, still finding nothing—nothing until he was passing by the Editorial Department for the second time, and he noticed, in the distance, a projectionist stomping out a just-finished cigarette and then heading back inside.

Junior did a double take. Sensing that something wasn't quite right, he began marching toward the screening room. There were no screenings scheduled for today. Not on a Saturday.

It must be his father. It had to be. Junior picked up the pace. What was he viewing? Rushes? But from which film? The questions skittered around his brain as he closed in on the door to the screening room.

"Junior!" a voice yelled from right behind him.

Junior turned to see Robert Florey trotting up to him. "Florey. Right," Junior said to himself as the memory of making an appointment to see Florey came flooding back to him.

"We had a meeting today," Florey said, catching his breath as he stopped in front of Junior.

"I know." Junior's eyes kept darting to the screening room door, just feet away. He had to get inside. Just tell Florey it was all a mistake. That his secretary screwed up and called the wrong person. On the other hand, if the test with Karloff didn't go well and he couldn't convince Whale . . . better to keep his options open. "I'm afraid I'm going to have to reschedule," he said hurriedly.

Florey looked at him, confused. "Really?"

"Yes, tomorrow. Be in my office at 9:00 a.m." Junior reached for the screening room door.

"On a Sunday?"

"Of course," Junior shot back, not really paying attention and then disappearing inside. In spite of being engulfed in darkness, Junior moved swiftly down a small hallway, with the *clack-clack-clack* of a projector running and the muffled sound of a movie playing leading the way. Reaching another doorway, the one that led directly into the screening room itself, he paused. Though the door was made of heavy wood wrapped in thick fabric, standing this close to it, the sound was loud enough that Junior could figure out which film was being screened on the other side.

And it honestly surprised him.

He carefully pulled open the door and was immediately greeted by the sight of a large movie screen filled with the piercing visage of Bela Lugosi as Dracula.

Junior slid inside and slowly closed the door behind him. He stood in the back of the small screening room theatre, waiting for his eyes to adjust. It was near the end of the film, and the chase was on as Dracula was being hunted. It took Junior about thirty seconds before his eyes had cleared enough to see anything besides the movie, and he finally spotted his father, all alone among the twenty or so seats, watching the film.

What does this mean? Junior wondered as he moved to one side of the room, trying to get a better view of his father. From this angle, he could see his face, with the reflection of the images dancing across his aged skin. Was he actually trying to understand these new movies? Was it possible? He was certainly watching closely, though with a look

that lived somewhere between curiosity and puzzlement. Maybe he was trying to come around on these new movies Junior wanted to make. It was almost too much for Junior to dare to imagine, but he found himself growing optimistic, even if it seemed that every time a character spoke or a door slammed or footsteps clattered down a flight of stairs, his father seemed to jump, as if hearing sound come from a motion picture for the first time.

But soon, Junior found himself drawn into the movie. Lugosi. As Dracula. That cutting figure. That face. Those eyes. Junior remembered the first time he had seen them. It was in person, on Broadway, a few years back, when Bela Lugosi had first become a star in the stage version of *Dracula*. There was something terrifying yet comforting in that visage of the mysterious count. Junior was scared of it, yet drawn to it. Frightened, yet intrigued. Pulled in, as if finding something, seeing something he had been in search of for a long time. But after the movie came out, even though it was a huge hit, the feeling was replaced by another one—that *Dracula* was a big step in the pursuit that he was undertaking but not the final step. Even now, looking up at the screen, something about that image of Lugosi as Dracula made Junior feel like a runner in a marathon, closing in on the finish line. Almost there but still a few more yards to go.

But there was another memory concerning Lugosi, one that took place in this very room and that was the cause of so much of the chaos that was happening now. Shortly after Lugosi had been cast as the Monster in *Frankenstein*, a screen test was made of him in full makeup. Junior had sat here and

watched it, and that's where his doubts about Lugosi began to kick in. Junior knew he wanted to make *Frankenstein*, but after seeing Lugosi as the Monster, he began to have doubts. Not about the movie but about Lugosi. Something just wasn't right in the way Lugosi looked when he was done up as the Monster. Something was off. Something was missing. Unable to shake his concerns, when James Whale came aboard as the new director, Junior put up no resistance when he wanted to replace Lugosi. So Lugosi was out, and Karloff was in—until Lugosi was in again and Karloff was out. And now, two days before the first day of shooting, no one was cast to play the part.

What a mess.

On screen, the stake was driven into Dracula's chest. The abrupt action drew Junior out of his memories. His father jumped back in his seat. A moment later, the film was over, and slowly, the lights came up in the screening room. Junior watched his father intently; he was unmoving, sitting silently, looking up at the blank screen. Just what was he thinking? Finally, he got up and headed for the exit.

Junior caught up to his father in the hallway, just outside the theatre. "Found yourself in the mood for a movie?" Junior asked playfully.

Surprised, his father spun around. "Junior. Working on a Saturday?"

"Just keeping things moving along. What did you think?"

"Same as I did when I saw it the first time. An interesting picture."

"I would say so. Our top grosser of the year."

His father nodded. "Yes. Yes. Very interesting." He stopped nodding. "But—"

"But, what?"

"But does that mean, do it again? This *Frankenstein*—"

Junior shook his head. "It's not doing it again. It's . . . it's . . . the next step."

His father just stared back at him, blankly.

Exasperated, Junior hung his head. "Answer me this, Pop. You find this repulsive, but you made all those movies with Lon Chaney."

"That was different. He was a huge star, and his films were nothing like this." He motioned toward the screening room. "Biting women on the neck. Coffins with rats in them. Stakes driving through the heart." He shook his head, dismayed. "And this next one—stolen cadavers? Reanimating the dead? Villagers with pitchforks and torches? What have you done to my studio?"

Junior shook his head. "You're missing the point." Suddenly, he brightened. "I've got an idea. Take a walk with me." Junior motioned toward the door with an outstretched arm.

Together, they hurried across the studio, walking in silence, with Junior leading the way. It took only ten minutes before they reached their destination—Stage 12. It was the largest soundstage on the lot and the largest in all of Hollywood. Nestled within the massive steel door, used to move large

pieces of equipment in or out, was a smaller, regular-sized door. Junior pulled it open and ushered his father inside.

He beamed with more pride than a new father as he shut the door behind them and stood looking at the massive interior expanse that stretched before them. This was truly his baby. Junior had it specially built as soon as he took over the studio. He'd used it for his first huge sound production, an adaptation of the hit stage show *Broadway*. A million-dollar production! Something Junior made sure was in all the publicity—Universal was spending big to win the future!

Since then, it had housed all of Universal's big productions, including *Dracula*, and now it was naturally being put to use for *Frankenstein*.

The cavernous soundstage was lit brightly from above by a network of work lights that lit up the backside of a bank of bare wooden stage flats that filled almost the entire space. They were arranged in a three-sided rectangle, with the unbuilt side facing away from them. Junior flicked a switch next to the door, and the work lights cut out, bathing the soundstage in darkness. Light flowed from over the top of the flats, beckoning them. "Shall we?" Junior said, again stretching out his arm invitingly.

With a slight nod, Junior's father followed him as they crossed the dark studio. Stepping around the back of one last stage flat, they suddenly were standing in the middle of the interior of a giant medieval castle chamber.

"Hold on a minute," Junior said as he stepped over to a control panel that sat atop a nearby table. He flicked a few switches, and the bare work bulbs illuminating the castle

interior cut out, replaced almost immediately by a huge swath of movie lights that had been carefully placed on stands or hung from the rafters, all around the set. "That's a bit better," Junior said as he rejoined his father.

In this much more refined lighting, the dark and dank interior walls of the castle rose up almost to the ceiling of the studio. Placed seemingly everywhere among the heavy, dark stone bricks was a menagerie of intricate metal panels, dotted with complex readouts; a series of hanging, smooth-polished steel balls; precisely blown glass fixtures; and intricate metal fixtures with repeating circular braces, all configured around a gleaming steel table, transforming the space from a medieval castle to a futuristic laboratory.

Junior scurried over and quickly slid the work lights aside. He stood proudly in the middle of the set. "What do you think?" he asked with a confident smile.

Junior's father took a tentative step forward, slowly, almost as if he were stepping onto a small boat and was unsure of his footing. He looked around, folding his lips into a slight frown, and nodded. "A nicely constructed set," he finally offered.

Junior hung his head and shook it. He slumped, defeated. "That's it; that's all you've got to say? 'A nicely constructed set'?"

His father looked it over again and nodded. "Good workmanship."

Junior threw his arms in the air. "This is the future, Pop! You're looking right at it!" He began to move quickly about the set. "It's what people want to see! It's what they need

to see!" He eyed his father and could see he was unmoved. "Hold on," he offered breathlessly as he raced over to the control panel. "When you started," he continued as he pushed some buttons, "films were simple things, silly little stories shot in a day, sometimes even in just a couple of hours. And that was fine, for a while. But then the audience grew up and wanted more."

Junior pushed a button on the panel. Suddenly the look of the set changed; gone was the flat, consistent, overall even look, replaced by sharp, contrasting regions of shadow and light, bringing the set dazzlingly to life. "So stories got more complex, deeper, more mature. More provocative. More challenging. But in time, the audience outgrew even that."

Junior pushed another button. Suddenly, parts of the set began to move: switches clattered to life, dials lit up, hands on gauges zipped back and forth. "They needed detail, nuances, touches of reality to convince them that what they were watching was real, not some fake thing put together on a movie stage. And films changed again, got even more real and sophisticated and compelling, and audiences lapped it up. But who could have imagined what was on the horizon?"

Junior pushed one final button, and as a low hum began to build in the sound stage, he walked back out onto the middle of the set. "Sound," he said as the hum was overtaken by loud crackling sounds as bolts of electricity began to rise all over the set, jumping between balled electrodes or climbing upward between towers like rising ladders of electricity. "Movies have come of age!" Junior shouted over the

raging din. "They have arrived. They have become more than you could ever have dreamed of." Junior turned away from his father and looked at the pulsing set as switches clacked, and gauges throbbed, and electricity danced all around. "They have become . . . They have become . . . " Overwhelmed, Junior climbed up on the steel table and stretched open his arms, as if pulling in the energy from the throbbing set. "A way to make discoveries, explore things. Get closer to the—"

Suddenly, all the lights in the studio burst back on. It caught Junior by surprise, and he turned around, raising a hand to help him see through the sudden glare. He spotted his father across the studio, where the light switch was. With his chest still heaving from his speech, he jumped down from the table.

In silence, his father walked straight toward him. "Yes, I can see," he said, reaching him. "You are in no way like the mad doctor."

Junior's whole body sank. "Why can't you understand? It has nothing to do with *Frankenstein*, specifically. This just happens to be the next film."

"Then what is it about?"

"It's about putting something great on the screen. Something new. Something never seen before." He looked right into his father's eyes. "Something fantastic!"

His father stared at him for a moment, crooking his head to consider Junior's words. Junior stared back, hopeful. Had his words finally sunk in?

But then his father swiped at the air dismissively. "'Never

seen before,' 'Something new,' 'Something fantastic.' *Echh!* None of this matters if the place isn't well run." With that, he turned and headed for the soundstage exit.

Junior exhaled, defeated, but then ran after him, joining him at the door. "Why can't it be well run *and* doing something new, something never seen before?"

His father stopped and looked back at him. "Perhaps. We will see." Together, they stepped out. His father's limo was waiting. "I should be off. I have a lunch appointment. I will see you tonight."

"Tonight?"

"Yes. Isn't there a premiere tonight? What is the picture?"

"*East of Borneo.*"

"That's it. I will see you there."

"Wonderful," Junior offered, with the best smile he could muster.

His father nodded a goodbye, climbed into his limo, and drove off.

Immediately, Junior's smile faded. There was nothing "wonderful" about it, nothing at all. His father rarely went to premieres and certainly not on a Saturday night when he could be down in Tijuana at a casino or at one of a dozen different card games around town. He really was taking this "checking things out" to the limit.

And that only made convincing Whale to accept Karloff all the more important.

.........

"K-A-R-L-O-F-F," Boris said succinctly, enunciating each letter precisely as he leaned out the window of his idling car. Only minutes had passed, but to Boris, it felt like hours. He was stuck at the main gate to Universal as a guard searched futilely on several different lists for his name.

Finally, the guard turned back to Boris, eyeing him through the window of the guard shack that paralleled the gate. "I'm sorry. I don't see your name anywhere."

Boris shook his head, annoyed. As recently as just a month ago, Boris had been at Universal almost every night for three straight weeks. Almost immediately after his chance encounter with Whale in the cafeteria, he'd started nightly sessions with the head of Makeup for Universal, working to perfect the look of the Monster. They had nearly finished—the look of the Monster almost there—when suddenly it stopped. Boris was told nothing, but later, he was to learn that Lugosi had come back into the picture, so Boris's services were no longer needed.

But now things had changed, and Boris was back in the mix, but apparently no one had told that to anyone at the front gate. "Could you just try it one more—" Boris pleaded but then paused, as a memory came back to him of that first night, when he'd had the first makeup session. Unable to look at the guard and feeling somewhere between embarrassed and disgusted, Boris hung his head. "Try it with a *C*," he offered flatly.

"A *C*?"

"Yes," Boris answered, still not able to look at the guard. "C-A-R-L-O-F-F."

The guard turned back to his lists, searched, and then brightened. "Ah, yes, there you are, Mr. Carloff."

Boris nodded sheepishly.

"Here's your pass." He handed Boris a slip of paper. "You're in the employee lot. I'll need you to turn around and then make a right. It's on the other side of the river."

Crossing a rickety wooden walkway that spanned the dry riverbed that was the L.A. River, Boris entered the studio lot. The usual shot of adrenaline he felt whenever he had a job at a major studio was lacking as the indignity of what had happened at the gate hung with him. When would it ever end? When would he finally achieve what he wanted so badly? And, thinking of the bridge in his mouth and his rotted teeth, what would be left of him when he finally did?

But as Boris walked among the stages, he pushed away the bad thoughts, returning to the goal at hand. Getting the role. Up ahead was his destination, a small bungalow in a nondescript corner of the studio, where he was to be transformed from Boris Karloff into the Monster for the screen test. This was where the head of the Makeup Department at Universal, Jack Pierce, worked and where he and Boris had toiled, experimenting on the look of the Monster. What exactly would a person made from the spare parts of several different people look like? Would each finger be from a separate person? Or would it just be a whole hand, or maybe an arm and a hand? What would the head be shaped like? Or the forehead? There

were so many possibilities, and with Jack's lead, they had worked through dozens of different ideas, finally coming up with something that they both liked.

Closing in, Boris used these last few moments of alone time to work through his thoughts on the character. After the phone call, with the disappointing news that he would have to come in for a screen test, Dorothy had entertained their party guests on her own, allowing Boris some time to review the script. He felt his approach to the Monster was solid. It was a continuation of what Whale and he had talked about; the compassion for this creation, for this outcast—that was the key.

He was almost to the bungalow, but even before entering, Boris could tell things were different. The door was open, as usual, but no sound was pouring out. Jack always had the radio on, playing music or, if it was late enough, a ball game. And when Boris entered, things felt even stranger. It wasn't that this was the first time he had seen the place during the day, or that his greeting—"Hello, Jack. How are you on this fine Saturday?"—was met with little more than a grunt in response. Or that the room—usually cluttered with empty makeup bottles, used brushes, soiled sponges, and wigs waiting to be returned to their prosthetic heads—was immaculate. Or even that Jack wore a clean white smock instead of his casual street clothes, as he had during their weeks of experimentation.

It was something more.

As Boris removed his jacket and shirt, exposing his bare upper torso, he tried a soft smile, but Jack ignored

it. Instead, the short fireplug of a man with brushed-back dark hair and wire-rimmed glasses over tight eyes attended with the focus of a surgeon to the splay of makeup and instruments that were spread out in front of a nearby three-piece mirror.

Boris sank into the oversized barber chair that dominated the room. "Just a little off the top," he said playfully. His words were met with icy silence from Pierce. Boris had been hoping to ease his tension with the light banter that had been constant during their weeks of experimentation, when the two men had worked late into the night, trying to get the makeup for the Monster just right. But clearly, it was not to be. Disappointed, Boris glowered.

He felt a hand on his shoulder, and he turned to see Willy, Jack's assistant. They'd met several times before, always at the start of one of the nighttime sessions, as he'd flittered around the bungalow, cleaning up from the day's work before going home for the night. He had similar features to his boss, with the notable exception of being taller and having a mustache. Clearly seeing Boris's consternation, Willy leaned into his ear. "He's always like this the first time one of his creations goes in front of the camera."

"Ahhh," Boris said, nodding. As Willy wandered away, returning to his own preparations for the job ahead, Boris exhaled knowingly. Of course, this wasn't just a big moment for him but for Jack too. It was opening night for both of them. No longer would they be experimenting; now, for the first time, their work was going to be seen by others. Recorded on film and judged. Boris knew all about how the

playfulness and silliness that might be the hallmark of week after week of rehearsal would vanish in a flash under a blanket of tension on a play's opening night.

Jack turned from the mirror and began to slick back Boris's hair with pomade. This was always the first step, and Boris settled in for what he knew would be hours in the chair. Done, Jack grabbed a thin brush, a small jar of collodion, and the first of dozens of cotton balls—all of which would be used to painstakingly create the look of the Monster—and again faced Boris.

But then he stopped.

Peering down through his glasses, with his chin pulled up tight toward his lips, Jack studied Boris's head. Boris had grown accustomed to this moment and always felt that Jack looked like a boxer awaiting the opening bell. After anywhere from a few seconds to a full minute of staring with his pugnacious face, Jack went to work.

........

Bela peered out from the wings of the Orpheum Theatre in downtown Los Angeles, eyeing the stage where five young boys were lined up, all dressed exactly like him in *Dracula*. His mood was already lifted by the packed matinee crowd giving his name rapturous applause in both the opening and closing credits of the just-completed screening of *Dracula*. But now, the sight of these children, all dressed up to look like him! In the role he created out of nothing! Bela could barely contain himself.

But then, hearing the voice of an emcee proclaim loudly, "If only we had someone special to judge our costume contest!" the glee left his face, replaced by a calm, focused, confident mask, very much reminiscent of the mysterious count the audience had just finished watching. Now ready, Bela stepped out onto the stage. Seeing him, the crowd at first gasped in excitement and then erupted with applause. Bela acknowledged it with several bows on his way to joining the children, center stage. A gaggle of photographers near the edge of the stage fired off several flash photos.

When the clapping finally faded away, the emcee took a step toward the front of the stage. "Who could be more special to judge our costume contest than Dracula himself, Bela Lugosi!" The crowd erupted in applause again. Bela bowed again.

The applause died down. "Well, kids, now's your chance to shine. Show us your best Count Dracula." With Bela watching intently, the emcee moved down the line, pointing at each child. The first child responded by lowering his head in embarrassment. The second ran off the stage. The third mumbled something that no one could hear. The fourth stepped confidently forward, swept his arm out majestically, and intoned proudly, "I am Count Dracula." The fifth just froze.

The emcee turned toward Bela. "Well, Bela, what do you think?"

Bela tilted his head back as he appraised the children and then turned to the audience. "They are all marvelous, but I always like someone who is not afraid to step forward and be

seen! There is no time in life to hide. Make yourself known. Be proud. Be out there!"

"Well, then it's clear to everyone that the winner is—number four!" Another round of applause from the audience. Bela joined in, clapping for the young boy who had just won.

The other children were led off the stage, and Bela stepped over to the winner and put his arm around him, causing a barrage of camera flashes from the photographers. Bela smiled brightly, delighted.

The emcee joined them. "Thank you so much, Bela." He then escorted them toward the edge of the stage.

But halfway there, someone shouted up from the audience. "Hey, Bela, come bite me! I want to be a vampire!"

The crowd laughed. Bela stopped and raised a bemused eyebrow. "The children of the night, vhat sounds they make when they've had too much to drink."

An explosion of laughter from the audience.

"Hey, Bela, what are you doing next?" someone else shouted up at him.

"Next, you ask?" Bela said with a droopy smile that was half amusement and half consideration. "Next, I vill play Dr. Mirakle in *Murders in the Rue Morgue*."

An intrigued "whoo" floated up to him from the crowd. Ever the showman, Bela seized the moment. His face sharpened, his eyes narrowed, and his entire body tightened as he made a sweep with his hand. "I em Dr. Mirakle, messieurs, mesdames. And I em not the sideshow charlatan. So if you

expect to witness the usual carnival hocus-pocus, just go to the box office and get your money back."

The crowd cheered again. Inside, Bela beamed.

"More! More!" the shout rose up from several spots in the crowd.

Of course they want more, he thought. *Words! Lines! Dialogue! I am an actor!*

Bela moved about the stage, almost stalking the audience, then moved forward to the very front lip. "I em . . . Dracula." Amid a storm of flashes, the crowd lost its collective mind.

Bela stepped out of the actors' entrance of the theatre to find a large crowd of fans waiting for him on the sidewalk. Smiling, he happily signed autographs, posed for pictures, and enjoyed the fun back-and-forth.

"I really love your voice," a young girl said, holding out a photo for his signature.

Bela gave her a genuine smile. "Thank you. And get ready for more!" He signed with a flourish.

"Hello, Bela," a voice called from behind. Bela turned to see Louella Parsons jostling through the crowd with a couple of young boys.

"Louella, vhat a pleasure," Bela said to her, with an ungenuine smile.

"I brought my two nephews to see *Dracula*," Louella said, pushing them forward awkwardly.

"I wanted to see *Bronco Billy*," the youngest said.

Louella gently pushed him behind her. "Such a joker," Louella said quickly. The photographers snapped a couple shots of Bela and his throng of fans. Louella grimaced from the flashes. "You don't normally make these kinds of appearances. What prompted you to do it?" she asked, with a leading smile.

"Vhy must there be a reason? Vhy can't I just love being wit my fans?"

Louella eyed him through lowered, not-buying-it eyelids. "Uh-huh. So, Bela, what do you hear about *Frankenstein*?"

Bela turned away to sign for others. "Vhy should I hear anything about that movie? I tell you months ago; I'm not going to do it."

"You also told me there was no truth to the rumors about you and Clara Bow. And we all know that's not true."

Bela gave her a broad smile. "Nice try, Louella, nice try."

"Well, anyway, I hear there are problems with *Frankenstein*. James Whale may be quitting."

Bela stopped mid-stroke and turned to face her. "That does not surprise me! Whale is a smart man. Who vants to do a movie about a stumbling idiot who says nothing? Who grunts like a moron?"

"And I even heard there might be a last-minute screen test happening. The whole thing sounds out of control, if you ask me."

"Vhat a disaster!"

"Completely out of control, like a monster terrorizing the countryside."

"Yes. Yes. A complete mess. An embarrassment. A true calamity! Vhat kind of actor vould vant to play that role! Vhat a nightmare!"

All around Bela, the crowd grew quiet, thrown by the outburst.

Bela's face returned to its Dracula pose. "My apologies. Sometimes the bat part of my blood takes over, and I get a bit riled up." The crowd laughed, loving it, and the fight to get a photo in front of Bela resumed, along with his signing.

"Any idea who they might get to replace him?" Louella said, helping her nephews get in close enough for an autograph.

Bela turned and grabbed both of her nephews' photos. "Louella, how vould I know? *Frankenstein* is not my concern." Finished signing, he handed them back.

"Thank you, Bela." Louella turned to walk away but then spun back. "But remember, if you do ever have anything to say about *Frankenstein*, you know where to reach me."

"I vill remember." Bela went back to signing, but as Louella headed away, he suddenly remembered the unexpected call from Junior the night before, when he was at dinner at the Russian Eagle, and slowly, his mood sank. He did have an idea of who they might get to replace Whale, and it worried Bela. If it was indeed Florey, then who would they get to direct *Murders in the Rue Morgue*? Some hack? Some imbecile?

Then, Bela's whole body turned to ice.

Or maybe they won't make the picture at all. Maybe the chaos of *Frankenstein* will infect the entire studio. Bring everything down. Make it all fall apart. As he went on

signing, Bela suddenly felt sick to his stomach. He truly did not want to play the part of the Monster, but his studio was in crisis, and he didn't want to come across as not being a team player.

I need to show that I'm there for my studio. Maybe it is time for me to make peace with Junior. I've made my statement. He has seen what happens when he does not treat me with respect. He knows. He's surely learned his lesson. Now it is time for my triumphant return, and all will be well.

I will be there in this time of need for the Big U!

........

The hours passed as Pierce worked in silence, sculpting Boris's head, face, arms, and hands, while Boris sat quietly in the chair, his eyes closed. Normally, he would nap or at least doze off, but today, as brushes and sponges and metal and cotton and paint were applied all over him, he found himself once again in deep thought about the Monster he was being turned into. The Monster he would be portraying.

Had he truly figured out the right approach?

He still felt that all that he and Whale had discussed worked well and still resonated, and Boris had incorporated that into his approach. But now that he was about to actually go in front of the camera for the first time—and getting the part was far from assured—he knew he needed something more. Something that would light up the screen and make them cast him. Something perfect. But what that was still eluded him.

He thought through the script yet again, but he had mined that for all there was, and ultimately, there wasn't a lot there. Mostly a description of the horrible things he would do—choking and crushing and drowning.

He thought through his most basic actor training. What did the Monster want? Did the Monster even understand that it wanted something? What was the Monster's purpose in the story? From the script, it was clear to Boris that he was the symbol of man's arrogance in relation to his God. That if man thought he could usurp the power reserved only for the Almighty, the ability to create life, then the end result could only be a disaster.

There was something in that.

If the ability to create life was a charade, then in spite of the Monster's ability to walk and move about, shouldn't he look as far from the living as possible?

At that moment, Boris felt the barber chair move and opened his eyes as it came to a stop, pointed directly at the mirror.

"What do you think?" Pierce asked.

Boris looked at himself in the mirror. The top of his head had been raised and flattened, with stitching and clamps around the top for where the Monster's new brain was supposed to have been deposited, all covered with a thin mop of dark hair. His forehead and brow had been raised and expanded, creating a sense of deep menace. All of his face was covered with mold-green makeup that, along with shaded and sunken eyes, elicited a horrific sense of decay. Metal bolts were jammed into his neck with all the subtlety of a hurried worker repairing a

power line. In a few simple hours, he had been transformed from a kindly English gentleman to a gruesome monster.

But Pierce wasn't done and applied some additional globs of thick wax to his eyelids, making them hang halfway closed, as though almost unconscious. *Yes. Yes*, Boris thought, *as far from living as possible*. Pleased, he turned to Pierce. "I think we truly have something here."

The costume went on quickly, with Boris slipping into a dark-blue wool tunic and then topping it with a black blazer. The sleeves had been shortened since the last time Boris tried it on, which explained why so much time was spent making up his lower forearms and hands, as they now stuck far out, adding a disturbing sense of disproportion. Dark trousers were next, finished off at the bottom by heavy asphalt-layer boots that were so bulky that Boris could lean forward several degrees without losing his footing.

Leading Boris like a child heading to his first day of school, Pierce walked him out of his bungalow and over to Stage 12. Along the way, they passed a pair of secretaries who were busy conversing with one another. But when they looked up and saw Boris, they both screamed and ran away. He and Jack shared a pleased smile.

When they reached the stage, Pierce helped him inside, and with his guidance, they navigated the spider's web of cables strewn on the floor and headed toward the set. All activity came to a standstill as the crew stared at him. Boris could see Junior and Whale, next to the camera, both eyeing him closely. Junior was clearly pleased. Whale was much more subtle, not entirely sure but definitely intrigued.

Boris was led up onto a small riser and placed in front of a nondescript dark curtain, the standard backdrop for a screen test. Then, after a final look-over and some tweaking with a brush and a comb, Pierce backed away. Boris was alone. Activity had returned to the stage, and looking out at the moving latticework of light stands, sound equipment, tripods, and crew members, Boris took it all in. This was his moment. His big chance. But how many times had he been here before? With success dangled in front of him, within reach, only for it to disappear in a flash?

But as he watched everyone work, a new feeling washed over him. Who was he kidding? *Success or failure, I'll never be able to let this go. Look at all these people working hard to create something great. This is what I want. This is where I want to be. I have to get this role because this is my chance to finally make it a real career, not just this hand-to-mouth existence that nearly killed me. I'll never be able to give this up because there's just no way I can. Even if it means literally rotting away.*

Two crew members placed a bulky movie camera about five feet in front of Boris, and a cameraman aimed it straight at him. Junior and Whale, along with an assistant director, took up spots right next to it.

"Stand by for picture," the assistant director yelled.

"Camera rolling," the cameraman shot back.

A crewmember jumped in front of Boris and aimed a slate at the camera. "Karloff screen test, take one!" he shouted and then quickly moved out of view.

Everything settled into position all around the soundstage. Boris was ready. Junior was ready. Whale was ready.

Whale leaned forward and raised a hand toward Boris. "And . . . " But then he lowered the hand and leaned back.

Boris stared at Whale, as did everyone else in the studio.

Whale stared back at Boris. "Actually, Boris. Would you mind turning yourself away from the camera and then, when we go, turning back?" Whale said matter-of-factly.

Boris nodded. "That would be fine." He slowly turned all the way around until his back faced the camera.

"Very good," Whale pronounced, pleased. "Very good."

What an interesting way to be revealed, Boris thought as he felt everyone's eyes on him—to first see the black expanse of his huge shoulders and back, and then slowly reveal the nightmare of his ashen, shadowy, living-but-not-living face. And wouldn't that just increase your compassion for this sad character? The more terrifying, the better. Yes. Yes. Maybe that was the key. But was there enough to reveal? And was it gruesome enough? Was there a way to go further? Go deeper?

"Stand by, everyone," the assistant director said as Whale leaned in, ready again.

Suddenly, Boris realized there was a way. He would go where his greatest fear was, to what scared him the most.

"Action!"

Just before turning, Boris's hand moved quickly toward his face.

........

Junior stood just outside the soundstage entrance, closely watching James Whale, who stood five feet away, intently

in thought. As the silence dragged on, he leaned against his nearby car, knowing it was important not to rush things. Junior had learned it was important to have patience when it came to dealing with Whale. German directors—Fejos, Leni—they wanted you to get in their face, to argue, to scream, let it all be very dramatic, dark, and angular, like a good German film, but not Whale. He was all about dignity. Yes, he had exploded the day before, but Junior knew that outburst was his way of making sure it was crystal clear that he meant what he said. It may have seemed crazy, but it was really the act of a focused, dignified man who wanted calm. So, Junior let Whale take all the time he wanted. He would stay calm for as long as necessary because calm was where Whale lived.

Finally, Whale turned and looked at him. "It could work," he said flatly.

Junior smiled.

"But I'm not giving you a definite answer until I get to see the actual test footage."

Junior nodded enthusiastically. "Of course, of course."

"Remember, I planned everything around Lugosi."

"And that's why we did the test. Once you see the footage, you'll be able to plan everything around Karloff."

Whale nodded, Junior's words sinking in a bit. "We'll see, we'll see. But it's not as simple as that."

Junior knew not to press things any further. The two men shook hands. Junior gave him a final firm smile and climbed in his car and drove away. He hurried across the lot; after all, he had a premiere to get to, but even still, he

couldn't help himself and punched the air. "Yes!" It would still come down to the test footage, but for the moment, he was pretty sure he had Whale convinced.

So much so, he had invited Karloff to come by the premiere once he was out of makeup. He wasn't just being magnanimous; he had another motive—it would give him a chance to subtly introduce Karloff to his father, so the old man wouldn't be surprised when he saw him on set Monday morning.

The premiere of *East of Borneo* was at the Fox Carthay Circle Theatre in Hollywood. A majestic movie palace that represented a double-edged sword for Junior. It was a grand theatre, worthy of the type of film Junior envisioned for Universal, but the fact that it was owned by Fox—one of Universal's main rivals—meant it was also a reminder of another time his father had missed out. Several years earlier, Universal had had its own chain of theatres, but his father had decided to sell them. And then when every other major studio started gobbling up theatre chain after theatre chain, Universal had stood on the sidelines, doing virtually nothing. So now, for any big premiere, they had to rent from a competitor. His father didn't seem to mind, but Junior found it more than a bit humiliating.

Despite driving as fast as he could, when Junior arrived, the screening portion of the night was over, and the crowd had already exited the theatre to the after-party, which was being celebrated in an enormous tent set up on an expanse of nearby lawn. *East of Borneo* was a romantic adventure story about a love triangle involving a mysterious prince, set in the heart of the Indonesian outback, and the party was

jungle-themed to match the film. Junior pulled up right in front, handed his keys to a waiting valet, and then hurried up the red carpet that was lined with screaming film fans.

He entered the party through the main entranceway in the tent, which was laced with abundant vegetation from the back-lot greenery. Almost immediately, Junior was greeted by a spontaneous round of applause from several guests sitting nearest the entrance. Pleased, Junior gave them a quick wave and hurried on. As he moved about the party for over a thousand guests, he was greeted the same way over and over. Clearly, the film had gone over well. Also, he was pleased to see, among the happy crowd, a fantastic array of movie stars. Not that he was that surprised; he knew full well that if there was one thing in this town that unified the highest star and the lowliest extra, it was the love of free food and free booze. He even spotted Louella Parsons in a corner, chatting away with someone who this time actually was Lew Ayres. All of it, the good reception and the good turnout, should make his late arrival all the easier once he found his father. On the drive over, he had worked up several good excuses, but none of them would be as effective as a strong premiere.

Junior looked toward the bar, where bartenders in jungle-native garb served drinks, and waitresses in grass skirts came and went, filling orders. This was exactly the kind of hokum his father loved, and Junior had a momentary panic at the thought of his father posing for the various roving photographers while making full use of the abundant native garb—or worse, the grass skirts. But fortunately, there was no sign of the old man anywhere near it.

Against the far wall, several of the rafts from the river-journey portion of the movie were being used to frame the sumptuous buffet. But again, there was no sign of his father.

Across the room, an explosion of camera flashes caught Junior's eye. A group of photographers surrounded a section of the set of the prince's palace, which had been brought in for the party, complete with palace guards at attention and a throne on a raised platform. Images of his father wrapping a turban on his head and, like one of the guards, playing with a sword filled his mind as he hurried toward the scrum.

Sidney stepped out, directly into his path. "Hello, Junior."

Junior came to an abrupt stop, almost knocking her over. "Sidney, so good to see you."

"Really, Junior?" she said, glaring at him through annoyed eyes. "So good that you couldn't pick me up like you promised."

Over her shoulder, he could see Bob and Tommy, again sheepishly holding their hats, move up behind her. "I'm sorry; things have been crazy."

"That was your excuse this morning. You know, when you skipped out on the Baby WAMPAS—which, by the way, went great, even without being on the arm of a studio head."

"I'm so glad to hear that."

"Are you, Junior? Because there were a lot of people there who seemed awfully interested in my career. I wish I could say the same for you."

"That's not true." Junior motioned past her toward Bob and Tommy. "I told you these two gentlemen had a very interesting story that—"

"*Hearts on Broadway*? Really, Junior? You expect me to buy that? Even Tiffany wouldn't touch that stinker of an idea."

Junior sighed. "Sid, please, you have to give me some time. Things are nuts right now. I promise you I'm working on something great for you. Now if you'll excuse me . . . " He moved to get around her.

Sidney blocked him. "Junior, that's not going to work this time. This whole thing with *Frankenstein* has gotten out of hand. You can't just keep ignoring my career."

"Sid, I told you, I am working on something great for you."

"You're lying."

"No, I'm not." More camera flashes at the bar caught Junior's attention. "Come by my office tomorrow morning, first thing, and I promise you I'll have something for you."

"Tomorrow? On a Sunday?"

He hesitated. "Yes." With that, he slipped around her and hurried across the room.

"You better be there!" Sidney yelled after him.

"I will!" Junior yelled back, with no idea if he really would be. But he didn't care. Tomorrow was a million years away, and right now, he was just trying to get through Saturday night.

Closing in on the palace set, he noticed that the palace guards wore big, ornate mustaches, curled up at both ends. Knowing his father, he knew this must be where he was. He would never be able to resist putting one on for the cameras.

Junior pushed through the throng of photographers, only to discover the subject of all the attention was none

other than Rose Hobart, the star of *East of Borneo*. She was posing playfully on the prince's throne, and the photographers were eating it up.

"Hiya, Junior," Rose said as she shifted, giving the flash-happy photographers another angle of her shapely legs through her gown.

Junior smiled. "Having fun?"

"Sure am!" She winked and shifted yet again, setting off another round of flashes.

Junior turned away and looked across the party, his eyes darting to all four corners of the room. No sign of his father, which was strange.

"Junior!" a voice bellowed so loudly that it pierced through the din of voices and music.

Junior turned around to see the studio bootlegger, Denny, standing before him in a tan camel's hair overcoat and gray felt hat and, as always, teetering on drunken legs as he loomed over Junior, as he did most people. Junior frowned; this was quite possibly the last person on earth Junior wanted to see at this moment.

"I know times are tough, but no tip? Come, now, Mickey's a good kid," Denny offered with a half-smile.

"Maybe I was a little tight after wasting my money on your bad information."

"What bad information? Now, knock it off. Where's the party?"

"You're at it, Denny," Junior retorted.

"No, where's *the* party," Denny continued. "I came all the way back out here to celebrate with you. I took the

trimotor! You know how to throw a party, and I know that becoming a VP would mean you would pull out all the stops."

"Then maybe you should have done a better job in your snooping around. Your info was bad. I'm not a VP. Not yet, anyway."

Denny belched. "Nonsense. I took action from three different board members after their meeting. They all said the board's vote had been unanimous. So what do you got in store? A yacht to Catalina? Maybe a blowout in Santa Barbara? Spill, Junior, spill."

Junior looked at Denny closely. Yes, he was often a drunken buffoon, but he was also a successful bootlegger, which meant he had to keep things straight, or else he would get pinched. And as far as Junior knew, Denny had never spent a single moment in jail. "Are you sure about what you heard?" Junior asked directly.

"Absolutely."

Junior studied him for another moment. "Okay," he said as he unlocked his gaze from Denny's face. So he *had* gotten the promotion, but his father hadn't told him. Without another word to Denny, Junior stepped away and looked all around the party, but he couldn't spot his father. In fact, he suddenly realized he couldn't find any of his department heads either. And even stranger, he didn't see his sister, and she was ubiquitous at these types of events.

His knees began to buckle as the gears in his head began to spin in all directions. Something was wrong. Very wrong. Then suddenly it all made sense—it was so obvious. "My

God," he muttered to no one in particular and rushed out of the party.

........

Bela stood next to a palm tree that had been brought in for the party, cradling a colorful tropical drink. He'd arrived late to the movie portion of the evening, taking a seat in the back, and was now enjoying the after-party. But as much as he had liked the portion of *East of Borneo* he had seen, he wasn't here for fun. He'd been pleased when he saw Junior Laemmle finally arrive and begin to search the party. Bela had watched Junior for the last ten minutes or so, rushing around, before losing sight of him in the thick crowd. He wasn't sure if Junior was searching for him, but it was clear that something was wrong, and Bela began to feel bad for him. After all, Bela had to come to the party to prove he was a team player, so maybe it was time to really step up. Clearly, things were chaotic with *Frankenstein*, and maybe Bela should reconsider. Maybe he could find a way to make the role work. If nothing else, to show the studio that he was there for them.

And then, suddenly, Junior reappeared, hurrying straight at Bela. As he closed in, Bela could see the strain on his face. Yes, this was clearly the moment Bela needed to be there for his studio. Bela opened his mouth to greet Junior warmly, but instead of stopping, Junior hurried past Bela without even looking at him. Perplexed, Bela watched him weave between the tables, avoiding every person who

wanted his attention, and then hurry out the main entrance of the party.

What was happening? Bela wondered. He looked around; the party was still going strong, and no one else had noticed Junior's rapid departure. But something was definitely amiss. He continued searching in vain for an answer, coming up with nothing, until his eyes landed on a tall, handsome man who was chatting up a young starlet at the bar. *Yes,* Bela thought, *perhaps he might know something.*

John Boles was originally a singer who, like many singing stars, was able to take advantage of their vocal abilities to make the transition to movies in this new age of sound. It didn't hurt either that he was tall, big-shouldered, and classically handsome, with a dashing mustache that had become all the rage with the rise of Clark Gable. Bela knew he had already been cast in *Frankenstein*, and they had met on a few occasions in the past, so Boles gave a warm nod when Bela sidled up next to him at the bar.

"How are you, Bela?"

"Fine. And you?"

Boles made a slight gesture to the young actress cooing next to him. "We will see." He winked at Bela for emphasis and turned back to her.

"Vhat do you hear about *Frankenstein*?"

Boles turned back to him, a bit irritated. "Only that we start shooting Monday, and you won't be joining us." He turned back to the young actress.

"Any idea who will be joining you in the part I turned down?" Bela asked to the back of Boles's head.

Boles turned back to face Bela. "I have no idea, but I hear they are looking—and maybe close to finding someone. But right now—no offense—I really don't care." Boles raised his eyebrows, knowingly. "Understand?"

"I understand." They shared a polite smile, and Boles turned back around. "Best of luck," Bela offered and walked away.

After Bela had initially turned down the role, of course he knew they would search for someone else. But once they had come back to him—again—he figured they had given up the search and were determined to only make the picture with him. But now, it turned out they were close to finding someone to replace him. *Who could they possibly find who is as good as me?* Bela mused. Fredric March? Billy Haines? John Gilbert?

Bela was determined to find out and began to swoop through the party, not unlike a bat, searching for the answer. He moved from table to table, trying to gain information. But none was to be found. It was only after scoring a seat next to an exuberant Mae Clarke that he finally hit pay dirt.

Mae was Universal's current "It girl," having scored a hit in the just opened *Waterloo Bridge*, and she too was scheduled to start on *Frankenstein* that coming Monday.

"I don't blame you for jumping ship, Bela," she intoned between puffs on a cigarette. "The whole thing seems rather ghastly." She briefly mimed a monster, causing the entire table to break up in laughter. "But I'm a good girl, and I do as I'm told."

"Sometimes it is good to do as you're told, and sometimes it is not," Bela shot back, unsure if Mae had been throwing a barb his way or just using a turn of phrase. "Any idea who they got to replace me?"

"No idea."

"I heard maybe Fredric March. Or John Gilbert."

Mae took another puff, blew it out, and then shook her head. "The only thing I did hear was that they were going with an unknown."

This hit Bela like a punch to the gut. *An unknown! To replace Bela! How could that be?* But despite the words raging in Bela's head, he kept his bemused mask in place. "Why does that not surprise me? Only an unknown would be stupid enough to take a role like that!"

"I suppose so. I don't want to talk about work anymore," Mae answered as she turned away from Bela and began laughing it up again with the rest of the table.

Bela rose, gave a bow to no one in particular, and moved away from the table. In an irksome mood, Bela searched for a drink, quickly finding one among a sea of pre-poured glasses of champagne on a nearby banquet table. But before he could take a drink, his attention was pulled to a table that was celebrating particularly loudly, and when a few of the guests slipped away to chase after an hors d'oeuvres–bearing waiter, Bela saw that none other than Clara Bow was sitting at the table, the center of attention.

Clara was in her element, her flame-red hair spilling in every direction as she laughed, drank, joked, and flirted with three men, all at once. Bela watched, enthralled. *That's the*

*way you do it. Not a care in the world. And why should there be?
You are a star!*

Suddenly, Clara turned toward Bela and caught his eye. Bela raised his glass to salute her. She responded with a playful roll of her eyes and then jumped out of her seat, much to the disappointment of her three suitors, and giggle-walked her way over to Bela.

"Bela, baby, how are you?" Clara said as she arrived in front of him.

"Better now," he said, playfully peering down at her. "And you?"

Without asking, she grabbed Bela's drink and took a swig. "I'm having fun."

"I can see."

Clara moved in a little closer to him. "You hear all those things they are saying about us?"

He smiled. "I have heard a few."

"Well, the best part is—most of them are true!" She laughed loudly and rocked her shoulders.

Bela laughed too. Their eyes locked for a playful moment.

"What do you say we get out of here?" she said, with an enticing peak of her eyebrows.

Bela grinned at her over his drink. "I can think of nothing I vould rather do."

⋯⋯⋯

Boris sat in the rear of the limo, pitched forward, unwilling to sit back against the leather seat. Even though Junior

had arranged it to take him to the premiere, he just couldn't relax. The test had gone well, as far as he could tell, but he still didn't know where all of this was heading. And he still didn't know if the role was his or not. After rounding a corner, they drove up to the Fox Carthay Circle Theatre, where the press and a lively crowd excitedly held vigil. A valet appeared, checked that the limo had the proper drive-up pass for the premiere in its front window—it did—and then opened the passenger door for Boris.

Boris stepped out to almost no response, but after taking a few steps up the red carpet, there suddenly was an explosion of camera flashes and cheers. He froze, confused, but then Clara Bow shot past him, hurrying from the party and heading to her waiting limo. She was a tiny thing, and Boris could see she was simultaneously enjoying the spectacle and overwhelmed by it. He laughed at the absurdity of it. Here he was, Boris Karloff, standing on a red carpet, and Clara Bow had just walked by. *Clara Bow!* The name rocked through Boris's mind as he watched her climb into her limo and drive away. Now a bit overwhelmed himself, he continued up the red carpet, eyeing the crush of fans on both sides and the sweeping bright lights overhead. He didn't know whether to be excited or scared. Was this what the future held for him? Or was he Icarus, flying too close to the sun, only to crash back to earth?

Reaching the entrance to the party, Boris was stopped by an oversized usher. "Can I help you?" he asked, staring down at him.

"I'm here for the party."

"Can I see your invitation?"

Boris did a double take; he hadn't been given one. "Oh, I don't have one," he offered nonchalantly.

"Then I guess you're not going to the party." The usher started to move Boris away.

Boris held his ground. "But I was invited by Junior Laemmle."

The usher looked at him, incredulous. "The head of the studio?"

"Yes."

"Sure, and I'm Baby Peggy." The usher, fed up, again began to move Boris away from the entrance. "Come, now. Move aside. Move aside."

"But I really was."

"I believe you." The usher then indicated the throng of excited fans, pointing directly at several of them. "And he was invited by Greta Garbo, and she by Groucho Marx. And look, there's John Gilbert's niece."

Once Boris had been moved sufficiently far from the entrance, the usher left him and went back to guarding the tent. Boris sulked, his mind reeling as he tried to figure out what to do. Maybe he could get a note inside to Junior? Or to anyone who might be able to help him get inside?

Then, any thoughts of his predicament vanished as another person stepped out of the party. It was Bela Lugosi. He was taller than Boris had expected and, as he watched him put on his evening coat and adjust it, oh-so-elegant and refined. He knew Bela had been mentioned, early on, for the role of the Monster in *Frankenstein* but had turned it

down. Why was that? What did he know that Boris didn't? Realizing there was only one way to find out and that he might never have another chance, he stepped toward Bela.

But at the same moment, the crowd discovered Bela's presence and let out a huge cheer. Hearing it, the press moved in and started taking pictures. Boris backed off and watched as Bela acknowledged all of it with a respectful nod and smile and then glided down the red carpet toward his waiting car.

Boris would have to talk to him another time. But one thought remained: Turning down work? Imagine the luxury of that! It was too much for Boris to even comprehend.

As Bela climbed into his car and drove away, Louella Parsons suddenly rushed out of the party. She started to head down the red carpet, but when she saw the car was too far away, she stopped. Glowering, she watched it go; then, spotting Boris, she hurried over to him.

Boris almost jumped back at her rushed approach. There was no end to the surprises of this evening.

"Was that Bela Lugosi in that car?" Louella hurriedly asked.

"Yes."

"Darn." She gave Boris a quick look-over. "You didn't happen to notice if anyone else got in the car with him?" She took a step closer to him. "Like, say, Clara Bow."

"She left before him. In another car."

"Rats." She gave Boris another look. "You don't happen to work at Universal, do you?"

"I might."

"Well, I hear there might be some things going on over there, having to do with Lugosi."

"You don't say."

"Some problems with *Frankenstein*. Word is, they might be trying out an unknown."

"You don't say."

"Yeah, that's how crazy it's gotten over there." Louella winked at him. "But don't worry; I'll get to the bottom of it. And then you can read all about it in my column. Because there is one thing you can say about old Lolly—she never misses a clue!" With that, she turned. The same usher who had harassed Boris instantly stepped aside, and she headed back into the party.

Boris shook his head in disbelief. Clara Bow, Bela Lugosi—and now, Louella Parsons, talking to him! He felt like a kid with his face pressed up against the window of a candy store. So many amazing treats on display, so close, yet he couldn't have any of them. For the moment, he had the answer to his earlier question. He was Icarus.

A cab pulled up in front of the theatre. Again, the crowd pressed forward in anticipation but sank when the door opened and out stepped neither a famous movie star nor director, but Boris's wife, Dorothy. Dorothy looked all around, overwhelmed, and then spotting Boris, headed up the red carpet toward him in a thrilled daze.

Boris watched her approach. She looked so magnificent. Just before he'd left the studio, not even thirty minutes ago, he had called her and told her to meet him at the premiere.

Somehow, in that short time, she had managed to put up her hair, do her makeup, and slip into a beautiful dress. As she drew closer, beaming and clearly loving the excitement, Boris realized he recognized the dress. He'd only seen her wear it one time before. Their wedding day.

"Oh, Boris! This is . . . this is . . . I can't believe it." She gave him a huge hug. "You know what this means? It means that you got the part."

"Well, I don't know about—"

"Oh, my God, do you know who I saw as we drove up?" She wasn't hearing a word Boris said; she was taking it all in, her face aglow. "Bela Lugosi!"

"You don't say."

"Yes! Just down the street, and I swear I saw him getting out of one car and then getting into another with Clara Bow. I can't believe we are here. And that we get to go in."

"Well, it's a bit more complicated than—"

"Come on; let's go!" Dorothy pulled him toward the door.

Immediately, Boris saw the usher spot them and move into position, ready to block their entrance. As Dorothy pulled him forward, Boris felt sick to his stomach. It was bad enough that she was about to be denied the thrill, but to put her through the humiliation . . . Desperate, he thrust his hands into his pocket and felt the $19.47 that was all the money he had in the world.

"You know what, Dorothy?" Boris said, stopping her. "The party's pretty much over."

"It is?" Dorothy responded, sinking.

"Yes. I'm sorry." Boris hung his head. "Everyone's heading home now."

"Oh . . . " Dorothy lowered her head, sulking. "I was really looking forward to seeing a real premiere party."

Boris stepped forward and lifted her fallen chin. He looked into her eyes. "But all is not lost. We have our own car and driver, and we've been invited to a whole bunch of after-parties, and we are going to as many of them as we can handle."

Dorothy's eyes brightened, and she started to clap excitedly. "Really?"

"Yes!" He motioned away from the party and toward the curb. "Shall we?"

"We shall," Dorothy answered, taking Boris's arm.

Together, they marched away from the premiere, toward the waiting limo, with Boris determined to show her the best night of her life. Or at least the best night $19.47 could buy.

........

Junior sped across town, his hands gripping the steering wheel and his eyes aflame. *How could I have missed it?* The thought raged through his mind. It was so obvious. He ran two red lights before turning sharply off Sunset and onto Benedict Canyon Boulevard and heading up into the hills.

After a few miles, he eased onto a side road and then continued snaking upward as the road grew smaller and tighter.

Near the very top, he approached a dead end—something that had come to symbolize, with each time he made this drive, where he feared the studio was headed if he failed— and pulled off the road onto a paved driveway. Up ahead, majestically dominating the hillside, was the grand visage of his father's house. Built in the popular Spanish style of the last ten years, complete with yellow earthen-colored walls and curved red-brick tiles, it was optimistically named by the home's first occupant as *Dias Dorados*, or "golden days," in Junior's native tongue. As recently as six months ago, it had been his home.

Junior initially loved the place. After all, in a rare agreement with his sister—who also grew tired of living in a bungalow at the studio or a hotel when they visited Hollywood—they had been the ones who talked the old man into buying the place. But over the years, the massive Spanish-style mansion had come to feel more like an ado-be-walled prison. So Junior had moved out.

Pulling into the driveway, Junior was greeted by the sight of about a half dozen cars up near the front door, all ringed around the circular drive. The fact that Junior recognized every single one of them only confirmed his fears—they belonged to his department heads. Junior eased into the one remaining spot, completing the circle.

Or is it a noose? he thought as he climbed out.

Junior stepped over to a heavy wooden front door and banged a metal knocker several times. A moment later, the door was pulled open by a tuxedo-clad butler. "Mr. Laemmle. Welcome," the butler said without a hint of surprise.

"Thanks," Junior responded, and without waiting for an invitation, he stepped past him into the entranceway of the mansion. It had been almost half a year since Junior had been inside the grand home. Then, all the furniture had been covered, as his departure—combined with his father being back East and his sister having moved out a few years earlier when she got married—meant the place would be empty. But now, there was not a white sheet in sight, and all of the furniture and accoutrements were dusted, spit-polished, and placed just where they belonged. The place was clearly up and running and, most concerningly for Junior, not for just a short stay.

Almost immediately, his sister, Rosabelle, appeared from another room. "Oh—Junior," she said, not as good as the butler at hiding her surprise. "We weren't expecting you."

"And I wasn't expecting you either. You've got the place set up quite nice."

"Thank you. Stanley and I have moved back in—easier to keep an eye on Father this way," she said, eyeing Junior to see his reaction.

"Why does this not surprise me at all?" he said sharply, as yet another piece fell frighteningly into place. "Now, where are they?" Junior asked as he hurried into the next room.

Rosabelle followed.

It was an ornate living room, dominated at one end by a large staircase that led to a second floor. The walls were covered with large Gothic paintings and tapestries, and the furniture was dark and solid and perfectly suited to the room.

"Who are you looking for?" Rosabelle asked as she watched Junior, surprised to find the room empty, come to a stop.

Junior was about to speak, but then his head twitched, and instead, he lifted a finger to his mouth, motioning for silence. A murmur. He turned in the direction of the sound and slowly crossed the room. As he approached the staircase, the murmuring grew into voices, talking, a group in conversation. But the sound wasn't coming from upstairs; it was coming from below, down another set of stairs that were only visible when you reached the far end of the voluminous room.

Junior broke away from Rosabelle and followed the stone stairs down, the talking becoming louder with each step. He stepped off the bottom landing and into a large room with a low ceiling ribbed by thick, dark wooden beams and a floor that was a giant tile mosaic done in the Aztec style, which had been all the rage when the place had first been built. In the distance, like an island in the middle of a great ocean, there was a cluster of sofas and lounge chairs, where sat six of Junior's senior department heads, including Rosabelle's husband, Stanley. They were dressed to the nines in tuxedos; each held a glass, and several smoked cigars. Standing among the haze of the intimate gathering, with his back to Junior, was his father.

As Junior hurried toward them, all six of his department heads saw his approach and jumped.

His father turned around, seeing him too. "There he is, bursting in like a mad doctor who has just found a miracle

cure!" He laughed to himself as Junior stopped next to him. "What a pleasant surprise. I wasn't expecting you at our little dinner party."

What had looked like a simple gathering from a distance was quite different when Junior got up close and noticed the stack of scripts next to his father and a pad and pen in each department head's hand.

"I don't remember attending many dinner parties where I had to take notes," Junior shot back.

Everyone but his father looked away, like a jury facing a man they had just condemned to death. "We were just . . . well . . . "

"I know what you were doing."

"Well, yes, it's just a review of all the projects that we have in development."

"You mean that *I* have in development."

"We . . . yes . . . "

"Okay, let's cut the bullshit. You're not out here to check out how the studio's running. You've come out to take it back from me."

His father shifted on his feet. "Ah, Junior, let's talk about this later."

"No. Now."

"Then let's at least go in another room."

"Right here is fine. You're not out here to check things out. You're not reporting back to the board. You came out here to take back the studio."

"It's not as simple as that."

"Actually, it is." Junior moved in on his father. "It's what you've wanted to do all along."

His father splayed his arms. "That is what you think? That this is how I wanted to spend my twenty-fifth anniversary in the film business? Dealing with this mess?"

Junior jabbed a finger in his father's direction. "Then why are you doing it? The board made me vice president, *unanimously*, and you blocked it! Why? Why?"

"The board! The board! A bunch of useless men who think because they can afford fifty-dollar suits that they know everything!" He sliced the air with his hand. "What does the board know about making motion pictures? I started this company from nothing! Nothing! I fought Edison and his thugs! I bought out all the little companies to make Universal what it is! Not them!"

"They still made me vice president."

"Yes, they did. But that does not mean I have to stand by and watch you destroy everything!"

His father motioned toward the stack of scripts next to him. "I do not understand these movies you want to make. Such strange material." He flipped through the pile, finally pulling out a copy of the script to *Frankenstein*. "And this *Frankenstein*—"

Junior ripped the script out of his father's hand. "This is the kind of movie we need to be making. Real. Powerful. Strong. Something new! Different than any other studio."

"Yes. You told me this before."

"Then why don't you get it? This is how we will survive.

This is how we'll thrive." He looked right at his father. "No gimmicks. Fantastic and thrilling movies, where they'll jump out of their seats and run out of the theatre—for real. Not some actress paid to do it!"

Finished, Junior dropped the script back down in front of his father. From all assembled, he was met with a deafening chorus of blank faces and silence.

Finally, his father looked at him sternly. "I'm sorry, Junior, but I just won't allow it."

Junior's entire body expanded in anger but then, just as quickly, deflated. "Then I guess there's nothing more to be said." Junior turned around and hurried away from the gathering.

His father watched him go, his face falling as only a parent's can when watching a misguided child.

Junior raced out the front door of the mansion, not really sure what had just happened or where he was going or why he was hurrying. Behind him, Rosabelle caught the door before it closed and watched Junior march down the front steps and climb inside his car.

He turned the key, the engine started, but Junior just sat there, not sure what to do. In silence, he peered forward, motionless, trying to come to terms with the whirlwind of the last twenty-four hours. From the high of discovering he was about to be made VP of all of Universal, to the low

of just discovering it had all been a charade. It was a lot, and all together, he didn't really know what it meant or where he stood. The promotion to VP was almost certainly gone, as well as his position running the studio. But was he still head of production? Working under his father? Or was he fired? It was all a confused mess, with nothing clear, save for one thing.

He couldn't make *Frankenstein.*

Suddenly, there was a knock on the side window, and Junior turned, to his surprise, to see his father standing there. Junior rolled down the window.

"Look, I want to be reasonable, Junior," his father began. "I have been really trying to understand these movies of yours. I really have. But I just don't. Especially this *Frankenstein.* Maybe there's a compromise here."

Junior tilted his head and eyed his father closely.

"How 'bout you don't make *Frankenstein*"—his father raised a finger before Junior could object—"but you do get to be a VP."

Junior tried to hide it, but he was genuinely caught off guard. He didn't know how to respond. He desperately wanted to make *Frankenstein,* but he also desperately wanted to be a VP. "Well, I . . . ," Junior began but then stopped. He had no words because he genuinely didn't know what to say.

Then, as only a father can, the old man sensed Junior's dilemma. "I have another idea," he offered with a crooked grin. "Before you give me an answer, how about we have a little fun?"

STONE

Junior followed closely behind his father's limo as they wove their way down to Sunset Boulevard and then turned left and headed into Hollywood proper. It was only on the last few blocks of their journey that Junior realized where they were heading.

Samuel Goldwyn's majestic mansion dominated a huge corner, less than a half mile down the road from Grauman's Chinese Theatre. Junior had been there several times for various parties and functions—Goldwyn was a well-known party-thrower—but when he pulled up, right away he could see things were different. Instead of the usual line of cars being attended by a battery of valets, there were just a half dozen or so limos parked out front, their drivers in a pack, chatting with one another. His father's limo parked; Junior did the same, and he stepped out to join his father on the sidewalk.

"Shall we go?" his father said, with all the ceremony of asking him to join him on an afternoon walk.

"Sure."

Junior followed him up the ornate walk, past the perfectly manicured lawn, between the majestic columns that lined the face of the house, and through the open front door. Instead of being greeted by the usual crowd at a Goldwyn function—the veritable cream of the crop of Hollywood milling about, being tended to by a bevy of waiters and servants—the house was empty. Junior paused for a moment, taking in the interior of the magnificent home—well known as one of the finest and most tastefully decorated in all of Hollywood—but his father kept going, crossing straight through the house and out the back door.

it's alive!

Junior followed him into the yard, and they walked together down a paved path dotted with small flaming pots, past a majestically lit pool, toward a sizable cabana. Seeing several men inside and hearing the murmur of voices— famous voices that Junior immediately recognized—he realized where he was.

This was the legendary studio heads' poker game. Everyone in town had heard of it, but almost no one had ever attended. You had to be at least a VP at one of the studios or higher. The game was famous for many things, among them, how late it started—after the studio heads had a chance to say good night to their wives, or their kids, or their mistresses, or, in many cases, all three.

The cabana was a rectangular structure made up of three solid walls, with a fourth—currently open so the occupants could look back out across the yard at a shimmering pool— made up of several heavy canvas flaps. Junior followed his father inside, and almost immediately after they entered, several servants pulled down the flaps, sealing off the room, and then left.

Junior looked around; the room was well appointed with comfortable couches, inviting chairs, tasteful fur- niture, and a big, round ornate poker table in the center, ringed by eight high-backed chairs. The other players, all of whom Junior recognized, were broken off into small groups, amiably chatting.

Goldwyn, Mayer, Zukor, Thalberg, Warner, Cohn— they were all there. Without saying a word to Junior, his father stepped over and joined in one of the conversations.

161

Not sure what to do, Junior wandered over to a buffet table to grab a drink. On it, instead of the usual elegant food served on glimmering silver, was a pile of corned beef sandwiches, a huge bowl of potato salad, another of coleslaw, and a couple dozen bottles of beer.

Junior grabbed a beer, opened it, and turned around to take it all in. There was not a single person in this city—in this town, in this business—who wouldn't drop whatever they were doing at that moment to be in this room, and here he was.

Without a word, his father took a seat at the poker table, and the others all followed suit. Junior took the last one, right next to his father.

Everyone settled in, placing their food and drink where they wanted it, arranging the stacks of chips in front of them and getting comfortable in their chairs. Junior waited, half wondering if there would be some sort of initiation.

There wasn't, as his father simply picked up a deck of cards, shuffled them a few times, and began to deal. "Junior here is joining the game," he said as the cards flew around the table.

"Great!" "Welcome!" "Nice to have you," and other greetings were casually tossed Junior's way. Junior returned them all with either words, a nod, or a smile. When the dealing was done, everyone picked up and studied their cards, and that was it. The game was on, and Junior was in.

The first hand was won by the host, Samuel Goldwyn, a modest pot that he claimed with three sevens. From there, the game proceeded with everyone taking a turn dealing, and no one dominating the winnings—yet.

Junior watched with interest. How strange it was to see the ferocious Cohn sitting next to the quizzical Goldwyn, next to the pensive Thalberg, next to the paternal Mayer, next to the mercurial Zukor, next to his father. They were some of the most powerful men in the world, men who ruled independent empires that employed thousands, with budgets in the many millions, whose decisions of what to put on the screen—and what not to—affected events in every corner of the globe. But now, they were nothing more than a group of men enjoying a friendly game of poker.

It reminded him of a few years back when his father's hometown in America, Oshkosh, Wisconsin, had thrown a day in honor of his father. They all had gone with him and watched, as he was very much feted as the prodigal son returning as the conquering hero. After all the ceremony and celebration, Junior had accompanied his father on a visit to the old department store on the main street in town, where he had gotten his start as their head of sales and advertising. Everyone was happy to see him, and the feeling was mutual with his father. After the pleasantries were over, a poker game broke out in the backroom— something that happened a lot when his father had worked there—and his father joined right in. They were there for hours, and Junior swore he had never seen his father happier, just playing cards and kibitzing around the table with his friends.

And that's exactly what he was watching at this very moment. A group of men who had all come from modest starts, enjoying a game of cards. He couldn't help wondering

if this group of glove makers, furriers, hat sellers, and song slingers would have remained furriers, glove makers, hat sellers, and song slingers if the movies had not come along. Were these men destined to find another way to make a mark, even if they hadn't created the most powerful and influential industry in the history of the world? A hundred years earlier, the best they could hope for was to be the richest men in the shtetl; today, they were some of the most important in the entire country.

And there was another thing, something that really surprised Junior—it was how they all deferred to his father. They didn't see him as the doddering old man that Junior did. They clearly respected him. How could this be? Many of them had bigger studios with much bigger stars and made enormous films with budgets Universal could only dream of, but still, they all—somehow, for some reason—seemed in awe of his father. It was subtle, but it was there. He was the leader. Not the wealthiest but definitely the one who commanded the most respect.

As the evening wore on, he began to see why. Though they would never come right out and say it, they all owed him a debt. He had fought and won the battles that had allowed their business to flourish and reach its current heights. Without him, they would be nothing.

This floored Junior. Had he been wrong about his father? Was he too caught up in today and not giving the old man enough credit for what he had done in the past, like they were? Yes, his father had missed a lot of things, but he'd also gotten a lot of things right. He'd created the star system,

he'd built the first modern studio, and he had one thing none of them had—his own city.

The farther they got into the night, the more Junior began to feel at home. He was losing, but he didn't care; they were all just friends playing poker—though he was reminded of who these men were outside this room when, after a particularly tense hand that came down to Warner facing off with Cohn, Warner raised $5,000 and Colleen Moore for one picture, to which Cohn called with his $5,000 and Barbara Stanwyck. Warner won with a full house, jacks high, and a disgusted Cohn threw down his three aces and proclaimed, "Don't you dare stick her in some shitty musical!"

Junior was truly in the inner sanctum. And he liked it. It wasn't until after 3:00 a.m. that Junior finally won a hand. They were playing draw, and right off the deal, he'd been dealt strong cards—four nines. Surely the winning hand, but he played it cool, not forcing things and letting others bid up the pot so as not to scare anyone out. He ended up walking away with the biggest win of the night, until then.

As he collected his winnings, his father—who had figured out Junior's strategy—winked at him. "See? Sometimes it's not so bad to play things a little safe."

Junior gave him a shy nod. "I suppose that can be true."

The others also chimed in, congratulating him on the win. No two ways about it; he liked it here, and, more important, he could stay here if he wanted to. Forever. All he had to do was not make *Frankenstein*: one silly little project, one of the dozens—no, hundreds—that would come and go every year. It would be so easy to just let it

go. How many times did they announce a project, only to see it not get made, just wither away and disappear, slide into oblivion? He could just let everybody wander off and take on other projects. Move Whale over to another movie. There was lots of great stuff coming up on the schedule that would be perfect for Colin Clive and Mae Clark. The rest of the cast and crew could easily be dispersed to other jobs. It would be a piece of cake. Just let it go.

It was such a simple bargain—give up one film and he's a VP. Then he could do anything else he wanted, as long as it wasn't *Frankenstein*.

It sounded like a pretty good deal.

It was Junior's turn to distribute the cards. He gave the deck a quick shuffle and dealt around the table. As each player studied his cards and then decided whether to fold, call, or raise, Junior eyed their faces. These men were his rivals—yes. But now, he felt they might be becoming something else. Friends? Perhaps; perhaps not. Acquaintances? Yes, but they had been that before tonight. What was it? What was different, now that he would be a VP? There—he said it. He was now a VP. The decision was made. There would be no *Frankenstein*, and he would become VP of the Universal Film Manufacturing Company. Not bad for twenty-three. And then it hit him—what that meant was . . . these men now were all his equals. There would be no more talk of nepotism. No more doubts. This was his world and where he belonged.

Chips flew around the table as everyone called, and the betting was done. Elated—he was going to be a VP!—Junior

picked up the deck to deal the next cards. But then he paused, suddenly feeling wetness at the back of his neck. He reached back to touch it, only to discover that his hands were already clammy. Then he felt something turn in his stomach. It started slowly but moved quickly, spreading across his chest and legs to the rest of his body.

"Excuse me, gentlemen," he said as he quickly got up from the table.

Junior opened his eyes, and the first thing he saw was the bottom of Samuel Goldwyn's sink. *My God, even that's nice,* he thought as he moved himself into a sitting position on the bathroom floor. The fit had been a quick, sharp one, and he had made it into the bathroom just before it got too bad, so no one at the table was any the wiser. But as his breathing returned to normal and the sweat that covered his body dissipated, he knew he wasn't completely out of the woods. He was now a VP. He had gotten exactly what he wanted, and yet it had still come.

Something was still not right. Something was still unresolved. Tonight, he had to confront it, head-on.

And he knew exactly where he had to go to do it.

.........

Bela had always been told that the sound of the ocean was good for sleeping. That might be the case for some, but on

this night, it was most definitely not working for him. Lying in bed, with the sound of the pounding surf flowing through an open window in the next room, Bela stared up at the ceiling. Minutes passed, but still, he could not sleep. Needing to do something about the noise, Bela climbed from the black satin sheets and grabbed his undershorts from the floor.

Slipping them on, he looked back at Clara, who, as this was her home and her bed, slept peacefully under the leopard-skin blanket that was strewn with their hastily removed clothing. They'd had a terrific evening together, hitting several night spots before, at her insistence, heading out to her beach house at the Malibu Colony. Though they hadn't seen each other in almost six months, the old chemistry was there, and she was completely understanding of his feelings about *Frankenstein*. Of course she was. She understood how the game was played. Bela regarded her for a moment—the sublime curves of her naked back, the perfection of her disheveled red hair, the pout of her inviting lips. Clara truly had it all. A true star.

Bela fished a robe out of the closet and, leaving the sleeping Clara behind, crossed a small hallway and entered another bedroom. This was a guest room, and it was perfectly appointed with some fine statues and paintings, all very tasteful and all just right. From the scattered encounters they had had over the years, Bela knew Clara was no expert at interior design, but the room showed the firm hand of someone who was. That's what it was like to be a star. If you couldn't do it yourself, you hired someone.

The window at the far end was open, and as Bela crossed to it, he was immediately enveloped by the sound of the

thunderous ocean below. From his perch on the second floor, he watched as the waves pounded ashore, tickling the raised front porch of Clara's beach house and the rest of the homes that stretched on down the coastline of the Malibu Colony. Over the years of their affair, they had always rendezvoused at her Beverly Hills home or, on one or two occasions, at a hotel downtown.

This was his first trip to the colony.

The nearly full moon bathed the second, third, or, in many cases, fourth homes of the very tip-top of Hollywood stardom in a suitable otherworldly glow. Bela had seen the full moon shine down upon him in the trenches in Europe, on the streets of New York, even through the window of his home in Hollywood, but here the moonglow was different. Soothing, calming, regal, a well-deserved beacon to those who had made it. Those who were stars.

Bela closed the window, the sound of the surf fading to a distant rumble, and headed back to the other bedroom to begin his quest for sleep again. But when he got there, the bed was empty, and the blanket had been pulled open on Clara's side.

Bela slipped back into the hallway and quickly descended a small spiral staircase that deposited him on the first floor near the kitchen. Everything was pitch black except for a small island of light in the distance, coming from the living room. Bela headed toward it.

As he got closer, Bela could see Clara sitting on a couch under a large bay window that looked out onto the ocean. She too wore a robe; with her legs tucked up under herself,

STONE

she was reading a movie script, using a small nearby lamp for illumination. Bela watched as she read and then mouthed the words to herself. But she seemed to be struggling, returning to the same lines over and over.

Finally, Clara began to riffle the pages, frustrated. "Words. Words. Words." Exasperated, she tried to rip the script in half, but it was too thick, so instead, she threw it across the room.

It landed at Bela's feet.

"Oh, Bela, sorry. I didn't hear you," Clara said with a laugh.

Bela bent down and picked up the script. "That is all right." He started to flip through it.

"Don't bother. It's crap."

Bela raised an eyebrow and handed it back to her. "Then vhy do it?"

"If you want the truth, it's gonna wreck the mood."

"Go on."

Clara sighed. "All right, I warned you. I walked away for a while. I had a bunch of pictures lined up, talkies, but I let them all go. I figured this whole sound thing would blow over in a year or two. But it didn't." She looked away, the frustration of the last few years coming back to her.

Bela had certainly heard the stories that she had been struggling with the transition to talkies, but every time he'd run into her, she was always the same old good-time Clara. He figured it was just another piece of made-up Hollywood gossip.

170

Clara turned back to him. "So, I came back. Started looking for new pictures. Talkies. The problem is, once you let someone else step in and do the job for you, and they turn out to be just as good, then you're screwed." She took a difficult breath. "So basically, Bela, honey, these days, I'll take what I can get."

Bela stared down at her, feeling from her the last emotion he ever could have imagined as associated with the Clara Bow he knew. Fear.

Clara giggled. "It's funny, Bela. All you want to do is talk, and all I want to do is keep my mouth shut." She jumped to her feet. "Now, come on, baby, let's have some fun." She wrapped herself around Bela.

They began to kiss, aggressively, passionately. Bela joined in, but having her this close, in his arms, there was no doubt about it. This woman, this indefatigable tiger, who three years earlier had shown up in his dressing room backstage in nothing but a fur coat—she was scared. He sneaked a peek over her shoulder, watching the reflection in the window of the fire-haired goddess in his arms, oozing and seething sex, charm, and charisma, burning bright. Clara reached back and turned off the light.

Suddenly, the image disappeared. Extinguished in an instant. With no warning. Just gone. Like it had never been there.

In the darkness, the kissing continued, but Bela began to tremble. *My God, if it can happen to her . . . What have I done? I've made a terrible mistake. I need to fix this. I need to call my*

agent. But then Bela remembered he was gone, ensconced somewhere up in the mountains, far from a telephone. As if sensing Bela's dilemma, Clara's passion grew, pulling Bela along with her. But then, slowly, he pushed her away.

"What's wrong, Bela?" Clara asked, confused.

"Nothing. I just realized who I could call."

........

"Then we saw John Gilbert, and Marlene Dietrich. Oh, and when I went to the ladies room, I swear Constance Bennett was in the stall next to me!" Dorothy squealed with delight. Across the table, her two friends, a young couple, listened, enthralled. "And then when we moved on to the Colony Club, who should we see on our way in?" She smiled broadly. "Joan Crawford!"

They all erupted in excitement.

Boris, seated next to Dorothy in the small booth, happily watched her go on with her excited retelling of the night's events. It was almost 4:00 a.m., and after a whirlwind visit to seemingly every hot spot in Hollywood, they had ended up at an all-night diner just off of Sunset. Dorothy had been insistent, using the cover of being a "touch hungry," but Boris knew the truth. She wanted to run into someone she knew so she could tell them all about their wild night, and this was just the place for that, as it catered to the not-quite-famous-yet Hollywood crowd.

Just hearing Dorothy tell her friends what they had done, even if she did occasionally exaggerate things a bit, made it

all worthwhile—even if his pockets were almost completely bare from having to slip each doorman a few bucks to get in. Plus, he had enjoyed it. Just driving up to each club in a chauffeured car had been quite the thrill. But as Boris sat there finishing his piece of apple pie, inside he felt more than a touch of melancholy.

Where did things go from here?

There was no question that he was one step closer to what he wanted, but it was far from being assured. Would tonight be like taking a sip of some exquisite wine, only to discover the rest of the bottle was empty?

A waitress zipped by and deposited the check on their table. Dorothy and her friends were still engrossed in excited conversation, so Boris grabbed it and headed over to the register to pay. He pulled out all the money in his pocket, counted out the appropriate amount, and handed it over to the clerk. After that, all he had left was twenty-six cents—a quarter and a penny.

"Anything else?" the clerk asked brightly as she finished ringing up the bill.

Boris caught a glimpse of a glass display case of cigars between him and the clerk. "Perhaps there is," he said as he searched for something to his liking. He passed over the expensive ones, finally landing on a box of five-cent cigars. "I'll take one of those."

"Very good," the clerk said as she bent down to retrieve the cigar.

Boris looked across the restaurant. Dorothy and her friends were just getting up from the table and putting on

their coats. She was laughing with them and having such a good time. Who knew what the future held? But tonight, he had made her happy, and that made him happy.

"You know what?" Boris said, causing the clerk to pop back up into view. "Give me one of those instead." Boris pointed to the other end of the display case at a box of twenty-five-cent cigars. *Tonight, I am an optimist!* he thought.

"You got it," the clerk answered as she quickly retrieved the more expensive cigar.

Boris took it and tossed her the quarter. "Thanks." Lighting the cigar, Boris took a deep puff and blew it into the air. Relishing the fine taste, he studied the single penny in his hand, all the money he had left in the world.

He tossed it in the air. "Heads," Boris said to himself. He caught it with one hand on the way down and slapped it onto the back of the other. Tails.

Boris frowned and tossed the penny in the air again. "Heads." He caught it again and slapped it onto the back of his other hand again. Tails.

Boris chuckled to himself. How fitting.

Was that all that was left? Chance? A coin toss? Fame or oblivion?

Or was there something more he could do?

Perhaps there was something. Someone he should see. Someone who had given him good advice in the past. Maybe just being around them might elicit some good information. Maybe? Or maybe not. But it might be worth a shot.

The only way to find out was to pay them a visit.

.........

Junior drove up to the back gate of Universal Studios and was greeted by the suspicious glare of the night guard. But the glare instantly vanished when Junior rolled down his window.

"Oh, Mr. Laemmle, I didn't realize it was you," the night guard said hurriedly through a smiling face, with just a tinge of please-don't-fire-me panic.

"That's all right. And you can call me Junior."

"Yes. Mr. Laemmle—er, Junior." The tension gone, the guard hastily lifted the single metal bar that blocked the rear entrance, and Junior drove in.

His hasty departure from the poker game had been uncomfortable at first, with his noncommittal excuses for leaving met with unease, until Thalberg chimed in, "I remember the night I made VP too. You give her a flourish for me." Everyone had laughed, and Junior was more than happy to play into the ribaldry to make his escape all the easier.

Being the middle of the night, he made it over the Cahuenga Pass in no time, and now past the gate, he drove a few hundred feet before stopping and parking at the exact spot where he had had the uncomfortable encounter with his father the day before. He stepped out and took a deep breath of the night air. It was comforting, in the way that the summer nights always were in Los Angeles. Somehow, no matter how hot and miserable the day had been, the nights always seemed slightly cool and idyllic.

From this vantage point in the rear of the lot, the entire studio sprawled before him. Being a Saturday night, everything was silent and motionless, as there were no shoots to prepare for the following day. Scattered clouds blocked the light from the sliver of a moon that hung to the east, and Junior began to walk in near-total darkness. Not that any light was needed; he could walk this stretch of earth blindfolded. He knew it better than any other real estate in the entire world.

He wasn't even seven years old the first time he had seen this former hog farm that his father had selected to build his empire upon. The entire family had traveled west on a special train, along with a coterie of executives, relatives, and friends, to celebrate the official opening of the studio in 1915. They arrived to much fanfare, initiating a three-day festival filled with huge crowds, celebrations, and a variety of publicity stunts. For the next ten years, he would go to school in the East, but his summers were spent in the West at the studio.

And this is where he truly came alive.

Returning to his New York City prep school from summer vacation, his friends would talk about visiting England and France; Junior would tell them about cowboy and Indian battles he had witnessed, the American army crushing the Hun, bank robberies foiled by G-men, and on and on. His stories easily outshined those of his globe-trotting friends.

Walking along in the darkness, Junior remembered how much he loved night at the studio. He found it thrilling how all the churning chaos of the day was suddenly brought to

a halt as the sun set, and piece by piece, everything was put away so it was ready to be used for the next day's filming.

The overgrown grass became a tended dirt road, and he came upon the first structures, the horse stables and saddle room. All was quiet. But the stillness mixed with the canopy of dark sky was like a cork being popped, and more memories came flooding back.

Passing the sleeping horses, he wondered if one of them had been the one Harry Carey had been riding the first time he saw him battle cattle rustlers, back in the summer of '19. Or was one of the seemingly hundreds of saddles tacked to the wall the one Laura La Plante was sitting on when she outran a gang of Indians who had just burned down her ranch house?

Next came the greenery, where thousands of plants, ranging from the potted indoor variety to massive palm trees used for exotic locales, stretched for what seemed like acres. How many of these had he and his sister and a seemingly never-ending menagerie of cousins hidden behind when they used to play hide-and-seek on any made-up set they came upon that was not in use at the moment?

Reaching the weathered storefront flats that made up a small section of Chinatown, a smile came to Junior's face when he remembered watching a furious gunfight between two gangs of bad guys while perched atop a camera platform, eating ice cream.

Even something as innocuous as the rug room brought back pleasant memories. Among the overflowing collection of rolled-up and hanging rugs of every variety that had filled

a sheik's tent or the drawing room of an upper-crust family, Junior had had his first kiss, when a cousin had brought along a cute friend with Mary Pickford curls to play with them at the studio when he was twelve.

But then, almost as a reminder that he was not there to live in the hazy glow of these memories but to confront something once and for all, he came upon the silent stages. They were still standing, in spite of Junior's order from the day before, the bulldozer sitting idle off to the side, having still not finished its job. *How perfect*, Junior thought as he seethed at the sight of this eyesore still standing in the midst of his studio.

But there was no time for this right now. Being so close to his final destination, he pressed on. Driven by the inevitability of what was to come, his pace quickened, with no time for remembrances as he hurried past the scene shop, furniture room, and costume building.

Approaching New York Street, Junior started to slow. All this time, he'd thought he avoided this part of the studio because of the judgment he felt that New York represented for him. But even with the promotion assured, the attack had still come. And hard. Something else was at play.

When he finally made the turn that put him squarely in the midst of the familiar buildings, he slowed further and apprehensively pressed on, moving through the darkened streets, drawn toward a particular brownstone up ahead. In the minimal light, any sense of the fakeness of the buildings vanished, making them indistinguishable from the real things three thousand miles away. So much so that Junior

reflexively dragged his fingers across the stone railing of the apartment building that was his destination as he climbed the front stoop. With each step, Junior suddenly found his mind drifting into the past. And by the time he sat down in the front doorway to the building, in his mind, this Saturday night in 1931 in Los Angeles had been replaced by a cool, crisp Sunday in New York in 1919.

Junior was just eleven years old and playing out in front of his building. Even though he was ensconced deeply in the Upper West Side of Manhattan, he was doing what he did on most days on the front stoop—looking to kill cattle rustlers.

And just like his favorite movie cowboy, Harry Carey, Junior leaned forward and peered over the railing, searching low and high for any sign of bad guys. But today, there was no one on the street, which was mighty unusual for these parts. There were always people bustling down the street with a baby or a delivery man with packages or school kids out playing—plenty of bad guys to protect his ranch from.

But on this day, as it had been for the last few weeks, there was nothing.

The streets were deserted; occasionally, the odd car trundled furtively along before disappearing from view, or a distant door would slam shut, and he'd hear footsteps and maybe catch a quick glimpse of somebody. But mostly it was slim pickings, so Junior had to satisfy himself with practicing his aim at the sign above the laundry across the street. He squeezed his eye shut, aiming for the W in Wang Fu's Laundry, and pulled the trigger.

"Pow!" Junior said loudly, knowing he had just hit a bull's-eye.

Junior was looking all around, searching for his next target, when a car drove up in front of the building. "Cattle rustlers!" Junior yelled and swung around to aim at the car. "A whole gang of them thar varmints!"

But when the door of the car opened, only two people climbed out. And one of them was his father.

"Pop!" Junior exclaimed as he rushed down the steps to meet his father on the sidewalk. He hugged him around the waist. "I didn't know you were coming back!"

His father returned the hug, distantly. "I needed to."

His father started to climb up the stoop; Junior followed happily. He was so happy his father was back. Things had been so strange around the apartment the last couple of days, and his father's return, Junior was sure, would bring everything back to order.

But when they reached the door, his father stopped him. "Here, Junior," his father said, handing him a silver dollar. "Go around the corner to the Regent. There's a good Harry Carey feature playing; it's one of ours. I want you to watch it at least twice. And get all the snacks you like."

"Sure, Pop!" Junior's eyes burst out of their sockets as he snagged the shiny dollar from his father, and before his father could change his mind, Junior hurried down the steps.

The streets were empty, except for a small pack of people who moved up the sidewalk right at Junior. As they passed, they nodded at him somberly, with the oldest—a tiny man with a huge gray beard—patting him on the head. Junior

ITT'S ALIVE!

recognized them from the temple. It was the rabbi and two of his assistants.

Junior looked back and watched as they met up with his father at the door to their apartment building. After quiet greetings, they all tied handkerchiefs around their mouths and headed inside.

Handkerchiefs around the face—Junior had seen a lot of that lately. It seemed everyone wanted to be a cattle rustler these days. That was fine with him; he'd root 'em all out.

The three-block trip went quickly, as the streets were deserted, except for one woman pushing a baby carriage. She was also clearly a cattle rustler, as she too wore a mask, and seeing Junior, she wisely moved to the other side of the street.

Arriving at the theatre, Junior went straight to the ticket booth. But it was closed. Confused, Junior walked past it and tried the glass door of the theatre itself. It was locked. He knocked. No response. He peered inside. The ornate lobby was dark and empty. He knocked again. Louder.

After a few moments, a lone man in brown wool work pants and a gray jersey shirt appeared. "Sorry, we're closed," he yelled through the glass door.

"But I want to see a movie."

"Order of the city—the flu's going around, kid. Now go home."

Junior had heard of the flu. Everyone started talking about it around the same time that everyone had turned into cattle rustlers. "But I still want to see a movie."

"Sorry."

"But it's one of our movies. My daddy made it."

The man looked closely at Junior, and then his head cocked back. "Gosh darn—you're Laemmle's kid."

Junior smiled at him through the glass.

The man sighed, pulled out a handkerchief, and tied it across his face. He unlocked the door and then opened it. Junior shuffled inside. The man backed away, not wanting to get too close to him, and then splayed an arm in the direction of the theatre. "Go on ahead. I'm the only one here. I'm afraid there's no one to play along with the movie."

"That's okay," Junior offered as he walked past him and into the theatre.

He quickly took a seat in the front row of the cavernous theatre. Behind him, way up near the top of the balcony seats, the man slid open a window to the projection booth. "Enjoy!" he yelled down to Junior as the projector started up and a bright beam of light shot out across the theatre.

Junior smiled as the words "Carl Laemmle presents" flashed across the screen in front of him, along with the familiar Universal globe logo.

He'd seen the film before, but within moments, he was caught up in the story as if watching for the very first time, and for the next hour, he was able to forget about all the strange things that had been going on for the last couple of weeks.

Finally, after several great shoot-outs, chases, and, of course, a grand rescue, the words "The End" flashed on the screen. Junior smiled, satiated, but then, suddenly, the film ran out, and bright light blasted the screen. Junior turned around and looked up. The booth was empty. With the

projector running all by itself, the tail of the just-finished film flapped about.

"Could I see it again?" Junior yelled. There was no response. He thought about trying again, but he knew what had happened. The man had left.

Junior left the theatre and headed home. A couple of hours had passed, but the streets were still deserted, and he reached the front stoop of his brownstone without encountering another single soul. He stepped inside. As it had been for the last week, everything was quiet. His mother wasn't feeling well, and the usual hustle and bustle of the house had come to a complete standstill. But now, his father had returned from the West Coast, and everything was going to be all right.

"Hello?" Junior called out but got no response. He slowly crossed from the doorway, through the living room and dining room, and still found no one. Even the kitchen was empty. He tried his bedroom and his sister's—also empty.

For the last week, he had been admonished to stay away from the other side of the apartment, where his parents slept and where his mother was resting. Junior headed down the hallway toward their bedroom. To his surprise, for the first time since he had been told to stay away, there wasn't a nurse sitting quietly in the hallway in front of the room. And Junior was even more surprised to discover that the door was slightly open.

Slowly, Junior headed down the hallway. Passing the guest bedroom, he heard voices through the closed door. Many voices. Though he couldn't make out any words through the heavy wood, he was pretty sure he heard praying. And crying.

At his parents' bedroom, he carefully pushed open the door. This room that was always filled with fun and laughter, where he had played for years, was still and empty and motionless. Though the room had several windows, the curtains were open to only one of them, sending a single shaft of light straight down onto the bed, illuminating the blanket-covered figure of an unmoving person. Junior carefully stepped into the room. Not only was the person's body covered but also the face.

If the window had suddenly burst open and the frigid winter air had enveloped the room, it wouldn't have been as cold as the shiver that tore through Junior's body. He knew full well who was under those blankets, and for the first time, he understood what had been happening. And what had happened.

His mother had died.

Alone in the room, he stared at the motionless body for a timeless minute, and then he turned to leave. But reaching the door, he turned back and looked at her. As if on their own, he found his feet moving, and suddenly, he was standing barely a foot from his dead mother. Her body was nothing more than a raised lump under heavy blankets, but the cloth placed over her face was thin and white and raised to a peak by her nose. Junior leaned over, his face just inches from his mother's face. He almost could make out details through the gauzy cloth but not quite. He wanted to see more. He needed to see more.

Junior grabbed the cloth and yanked it away.

One day until the first day of filming on *Frankenstein*

Junior awoke the next morning, his body pulled in tight around him to keep warm, as by dawn, a slight chill had set in, and the brownstone doorframe, which had been his bed, offered almost no protection from the elements. It had been years since he had fallen asleep on the back lot, something that had been routine for him as a kid, when he used to camp out with a bevy of cousins. But last night had been anything but a fun sleepover.

As the sun rose, burning away the morning haze, Junior climbed to his feet. His own vision cleared too, for now he knew exactly what had to be done. Exhausted and his body aching, Junior marched away and into the new day.

Not even two hours later, Clancy pulled the limo to a stop in the empty parking lot of the Hillcrest Country Club, and

Junior climbed out. He was freshly bathed and clean-shaven, and his suit looked like it had been custom-made the day before. Though it was hours before the brunch was to begin, Junior knew his father would already be there; determined, he headed for the front entrance.

As was the custom, his father's traditional Sunday brunch was held on the expansive patio on the backside of the main building that overlooked the golf course, and as Junior walked among the sea of tables, waiters scurried about, adding finishing touches to each place setting. Not surprisingly, Junior found his father in the kitchen, with a sample of each item of the upcoming brunch spread before him on a table. He was tasting some smoked salmon, and his brow furrowed, as if he were considering a fine wine. The sight was a familiar one to Junior; he knew how important these Sunday brunches at Hillcrest were to his father. The big showy banquets, like the other night, were for the people Universal wanted to impress, but the brunches, they were for the ones his father wanted to impress—family, friends, and the real power brokers of Hollywood.

Finally, his father nodded his approval to a nearby cook. "But remember, no dry edges, understand?" The cook nodded that he did.

Junior finally reached his father, as he had moved on to inspecting a platter of whitefish.

Seeing Junior, he held out the plate for him. "Good morning, Junior. What do you think of this?"

Junior grabbed a nearby fork, tore off a hunk of whitefish, and tasted it. "Tastes fine."

His father grabbed his own fork and sampled it himself. He shook his head. "Too salty." He handed the plate to the cook. "Try again."

His father moved on to a pair of ice sculptures. One showed Junior and his father shaking hands, with the letters *VP* across the bottom; the other showed the Universal globe with the letters *VP* stamped across it. He turned to Junior. "I can't decide. Which do you like better?"

"Neither."

"What do you mean, 'neither'?"

"I'm not taking the job."

His father tilted his head back, incredulous. "What do you mean, you're not taking the job?"

"Are you going to let me make *Frankenstein*?"

"I thought we settled that last night. You pass on making *Frankenstein*, and you get to be VP."

"I never agreed to that. I have to make *Frankenstein*."

His father shook his head. "No."

"Then I guess I quit." Junior turned for the door in a hurry.

His father stepped after him. "Do you know why I put you in charge of the studio?"

Junior stopped and spun back to face his father. "Because you finally had a good idea. You realized things were changing, and you needed someone who could see the future, who understood it."

"No, because you always had so many ideas; you were all over the place, and I thought if I could force you into responsibility, it would make you concentrate. But it didn't work; you're still all over the place."

"I've never been more focused in my life."

"You're worse than ever."

"But my ideas have worked."

"Perhaps. But at some point, they're gonna stop, and I can't wait for that moment. I can't wait for you to crash and burn. I can't let the whole studio go down with you. *Frankenstein*? It's not worth the risk!"

"It is to me!"

"All right, Junior, how about this—when all the executives get here, I'll put it to a vote. If they agree we should make the film, then you can make the film."

"No. No more games. No more stalling. You and I both know exactly how that vote will go. Enough. You said I was in charge; then you need to let me be in charge. Am I in charge?"

His father teetered on his feet as if considering. But nothing was said, and in the silence, Junior heard him loud and clear.

Junior cracked a quiet smile. "I never really was in charge, was I?"

Suddenly, his father became very animated, pacing in a circle and finally throwing his hands in the air. "*Why*, Junior? Why do you have to make this film?"

An odd calm washed over Junior. "Not for any of the reasons that you, or Sidney, or even Louella think." Junior slowly shook his head and sighed. "I just have to." Then he broke into an almost thankful smile. "All this time, I thought I was chasing the future, when what I was really chasing was the truth."

He turned and walked out of the kitchen.

Junior hurried back across the patio. The waiters had finished, and everything was set for the imminent arrival of the guests. Passing the main table, he spotted his sister, Rosabelle, rearranging the placards, moving a pair of them closer to the head spot. "Don't bother," Junior said, without breaking stride. "It's all yours."

Moments later, Junior climbed back into the limo, and Clancy drove them away from the country club.

"Where to?" Clancy asked as they pulled out onto Olympic Boulevard.

Junior had no answer for him. Nothing. He had no place to go. He had no place to be. In silence, Clancy kept driving, and Junior just stared out the window. Not that he saw anything. He was lost. He didn't belong anywhere. He was cast out. He was adrift in a city, surrounded by people rushing all about because they knew what they were doing, had a purpose, and were doing something to get it.

But not Junior. Not anymore.

They drove around for hours, finally settling on an orbit around the city that saw them passing through Hollywood on Santa Monica Boulevard, up Highland Boulevard, back across the top of the mountains on Mulholland Drive and down Beverly Glen Boulevard, and then back through Hollywood again on Santa Monica Boulevard.

"Stop!" Junior finally yelled as they again crossed high above the city on Mulholland. Clancy quickly pulled them

over to the side of the road, and Junior climbed out. He moved to the edge of the cliff and peered down. Almost all of Los Angeles was spread before him. But unlike the view from his apartment, where the city appeared as one giant metropolitan splay, from this high up, each of the studios jumped out at him, like little nation states, little feudal empires that dotted the landscape. Junior had once been part of one, had run one, had been a king. But now, he was deposed, left to wander like a gunslinger in one of his Westerns.

But there was no reason it had to stay that way.

He would keep moving forward. He had to. What he had done worked. Others knew it, even if his father didn't. And he was so close to the truth. He would not be stopped. He would take his vision elsewhere and, more importantly, to a place where he could make *Frankenstein*.

Filled with a sudden sense of urgency, he leapt back into the limo. "Home!" he shouted to Clancy, and as Clancy turned them around, heading back into Hollywood, Junior began to scheme. MGM was known for musicals, but he had always gotten along well with Thalberg, and Thalberg felt a bit of a kinship with him—he too knew what it was like to be thrust into a powerful position at a very early age. Of course, there was always Zukor over at Paramount. Rumor was they were going to hop on the mystery men bandwagon, and they were going to make *Dr. Jekyll and Mr. Hyde* in about a month. They just might be a studio that got it, that understood what Junior was doing. What he was after. And of course, there was always Warner Brothers. He and Jack had always—

Suddenly, through the passing trees, Junior spotted the Universal Studios lot in the distance. Flashing by like an image in a giant zoetrope, his former home blinked at him. Almost calling to him, signaling him. And that's when Junior realized he still had one bit of unfinished business. One last thing he had to do, whether he was still running the studio or not.

Junior fired up the bulldozer and began to drive across the studio. From his earliest days as a boy hanging around the lot, one of his favorite places had been the motor pool. The largely open-air space was where Universal worked on and housed the various buses, trucks, jalopies, motorcycles, and even construction equipment used to run the studio. As the son of the boss, Junior was given free rein and quickly learned to drive a whole series of different vehicles.

And happily, to Junior, at this particular moment, that included bulldozers. With its diesel engine belching thick, dark smoke and roaring louder than an angry lion, he easily steered the bulky vehicle through the various roads and streets to his destination. One way or another, he was going to finish what he started at Universal.

The silent movie grandstands were bathed in the golden midday sun when Junior drove along their backside. He drove about fifty yards away, to approximately where the long-since-demolished silent movie stages had stood, and began to swing the bulldozer around to attack the stands

head-on. If his father was going to take the studio back from him, then he would be getting it back fully transformed.

The past would be dead.

Junior finished turning the thundering dozer in a small arc, and then, aiming straight at the heart of the grandstand, he pushed the controls forward. The engine roar turned into a scream, and the two-ton metal beast, leading with its massive clawlike scoop, thundered forward. Junior gritted his teeth, anticipating the impact and the coming satisfaction of the splinter of the rotted and weathered white wood. He wouldn't just be burying the past. He would be shattering it, destroying it, making sure it could never come again.

But as he drew closer, he noticed a lone figure among the empty stands. A single dark point among a sea of white. About fifty feet out, he realized it was a man in a dark suit, sitting in the stands.

It was his father.

Junior grabbed the controls and, using all his strength, yanked them back. Fighting with the bulldozer, he finally came to a complete stop about five feet short of the stands. Relieved, Junior quickly shut down the trembling beast and leapt onto the ground. He stared up at his father, who was looking off into the distance, past Junior.

Junior stepped around to a small staircase, and very deliberately, with the wood creaking underneath like it might give way any second, he climbed. In silence, he reached the top and joined his father on the grandstand. Nothing was

said as the two men sat in silence, a few feet apart on the simple wooden bench.

Finally, his father motioned out into the distance. "I remember the first time I came out here to California," he began, his eyes still fixed forward. "You couldn't have been more than five or six at the time, just a little *pisher*, and Universal didn't even exist. We were still the Independent Moving Picture Company."

"The IMP," Junior added, trying to be helpful.

"Yes, the IMP," his father shot back, eyes still fixed forward but with a slight smile. "We were still fighting with Edison and the patent wars, and things had gotten a bit rough, so we sent a crew out West to make films away from all the craziness. I went to check on things. It was in January, and I boarded the train at Penn Station in the midst of a snowstorm. For five days, I rode across the country, my head buried in production reports and scripts and updates of the court cases with Edison." A big smile bloomed onto his face. "Then we made it to California. I stepped off the train into paradise. It was seventy-five degrees out. In January. I remember leaving the station, and just outside the exit was a young boy selling oranges. He had a huge cart of them. Fresh oranges. Fresh oranges in January. I thought, *This is truly the garden of Eden.*"

He finally broke his gaze into the distance and looked around, almost as if seeing the studio for the first time. "So much has changed since then," he said, somewhere between pleased and resigned.

"Yes, it has."

His father turned and looked at him. "After you left, I did ask all my executives what they thought of *Frankenstein*. To a person, not one of them thought we should make the film, not one of them. Nobody thought it was a good idea."

Junior tightened his lips. "I can't say I'm surprised."

"The funny thing is, Junior, when I wanted to buy my first movie theatre, nobody thought it was a good idea. When I opened my first exchange, nobody thought it was a good idea. When I wanted to start making my own movies, nobody thought it was a good idea. And when I wanted to open my own studio, still nobody thought it was a good idea. But you know what I told them each time?"

Junior looked at him blankly.

"I just have to," his father said with a grin. "This studio exists because I didn't listen to anyone. Maybe it's a good thing you don't listen to anyone too." He turned and looked right at Junior. "You go ahead and make your movie."

"Really?"

His father turned over his palms. "I will never understand why anyone would want to make *Frankenstein*, but maybe that's a good thing."

The two men shared a moment as only a father and son can. Carl reached an arm out and put it on Junior's shoulder; Junior did the same. The two men leaned toward each other and hugged, shoulder to shoulder.

They parted. Nothing was said. Nothing needed to be.

In the distance, a car appeared, driving toward them. "Ah, here we are," his father said, as if his taxi had finally arrived.

Junior followed his father off the grandstand to the ground below. The car pulled up near them, and Louella Parsons climbed out.

"What in the world?" Junior's mouth hung open. "What is she doing here?"

"I asked her to meet me here. We're having lunch. Wish me luck. You know how she can be. If she corners me just right, I'm afraid I just might slip and tell her about Universal Pictures' brand-new vice president." He flashed Junior the smile of a proud father.

Before Junior had a chance to return it, Louella stepped straight toward him.

"I'm angry at you, Junior. I would have liked to have had the scoop a couple days ago."

"Well, you've got it now."

"Yes, I do. How would you like it if I kept information from you when you needed it?"

Junior grinned. "Now, Lolly, I know you would never do that to me."

Louella gave her best melodramatic sigh. "Sadly, you're right, Junior. Besides, it turns out I was wrong. You weren't an out-of-control monster, and I owe you an apology."

Junior didn't know where this was going, but he was enjoying it. "Why's that?"

"Because I said you were lying when you said everything was fine with *Frankenstein*. Well, now I know you weren't lying. Lugosi called me."

Junior blinked. "Did he now?"

"About an hour ago. He told me how excited he was to play the Monster, and he couldn't wait for Monday," Louella said matter-of-factly. "He was quite enthusiastic."

Junior did a double take before playing it off. "Well, there you have it" was all he could manage.

His father nodded approvingly, just as Louella turned to him.

"Uncle Carl, I'm starving," she said playfully.

"Me too. We better get going because if I don't eat soon, my mouth might just run and run."

"Let's take my car," Louella said, ushering him toward her waiting vehicle.

As he was led away, his father suddenly turned back, momentarily stopping. With wistful resignation, he eyed the silent stands, regarding them one last time. "I'm the reason these are still here. I've been blocking it every time you tried to tear them down."

Junior laughed. "That's good to know."

The old man sighed. "Honestly, a part of me is relieved. It's exhausting fighting the inevitable."

"I can imagine."

"But that's only my part of all this, Junior. Earlier, you talked of the truth. I still haven't heard exactly what that is. And I'm not really sure if you know."

Junior gave a slight nod. "I may not. But I'm going to keep searching."

"You do that." His father climbed into Louella's car, and they drove away.

Junior watched them drive off and then turned to a

couple of workmen who had arrived to deal with the bull-
dozer. He pointed at the grandstands. "Gentlemen, if you
wouldn't mind . . . "

The workmen nodded their understanding, and Junior
headed for his office. Behind him, the bulldozer began plow-
ing down the grandstand. Finally.

He strolled across the empty lot; his father's parting shot
had irked him, but Junior let it go. This had been a tough
day for the old man—finally, truly letting Junior be in
charge—so he could forgive his father for perhaps one last
bit of nastiness.

Besides, he had a movie to make. And that meant it was
time to let Bela Lugosi know he was going to be the Monster.

.........

The young girl sitting on the side of the road looked up from
her movie magazine as Bela's car pulled up and parked right
in front of her.

As Morlan stepped out from the car and quickly opened
the back passenger door, the girl arranged the fresh flowers
in the bucket in front of her, attempting to make them as
appealing as possible to this potential customer.

Bela stepped out and walked over to her. Clearly recog-
nizing him, she shifted in her seat and looked up, wide-eyed.

Bela smiled. "Sometimes, I have no choice but to come
out in the daytime." He pointed at a stack of printed flyers
that were next to her on an empty chair under a handmade
sign that read, "Gravesite map, 5 cents."

"I'll have one."

The young girl lifted a rock that was keeping the flyers from blowing away in the early morning breeze, and handed one to Bela.

Bela fished through his pockets before pulling out a dollar bill, but then he paused before handing it over. Drawn to her bucket of flowers, Bela examined them until, with great drama, he chose one. A perfect red rose. "Keep the change," he said, handing over the bill. Carrying both the rose and the flyer, Bela got back in his car, and Morlan shut the door behind him, slipped behind the wheel, and drove off.

Looking back, Bela eyed the young girl, who watched as the car pulled into the nearby cemetery. He chuckled to himself.

Oh, how disappointed she would be if she knew that Bela wasn't there to search for bats or stalk some prey. No, Bela was there because, given recent events, it just seemed the only logical place to go, especially with the way everything had turned out. After all, he was going to be the Monster in *Frankenstein*.

Leaving Morlan behind at the car, Bela strode across the freshly mowed green grass. As he moved among the gravestones, he slowed to check the map in his hand, his eyes searching for the words "Lon Chaney." Finding it, he confirmed that he was heading in the right direction and pressed on.

With each step, as if being surrounded by all of this anonymous death inspired him, he felt better and better about his

choice. Chaney may have been a fool to let himself be hidden from the world, but Bela would find a way to carry on his tradition of incredible transformations, while still having a face the world knew. He would do both—become famous as the successor to Lon Chaney but also not let his image, his being, who he was, be lost to eternity.

Up ahead, he finally spotted another person. And as Bela drew closer, as if confirming that he had made the right choice, he was comforted to discover this other person—a tall, skinny man—was standing at Lon Chaney's grave.

.

Boris jumped back a bit, startled when someone joined him as he stared at Lon Chaney's gravestone. He'd been there for almost half an hour, arriving just as the sun appeared in the east, the first and—until now—only visitor to the cemetery. He was even more surprised when he looked over and discovered that his companion was Bela Lugosi. The two men stood in silence as the sun rose higher and higher amid a growing chorus of chirping birds.

"Hello," Boris finally offered.

"Good morning," Bela answered without breaking his gaze on the headstone.

"Did you know him?" Boris asked, with a head tilt in the direction of the grave.

"A little bit. We did a movie together a few years ago. A fine performer."

"Yes. One of the greats. And a very nice man."

Bela turned toward Boris with a raised eyebrow. "You knew him?"

"For a time, back in the early twenties. He used to give me advice on my career, and I came out here, hoping to remember it."

"And did you?"

"Yes. He told me the key to success in Hollywood was to find a way to make yourself unique. Stand out. To be something that no one else was."

"That seems like a strange thing for a man to say who spent his whole career never seen by anyone. Hidden. Under pounds of makeup."

"Perhaps that was his unique thing. The transformations he would go through."

Bela considered Boris's words for a time. "Maybe. But I can't imagine letting no one ever see you. Your face hidden. Your image lost."

"It worked pretty good for him. It is one way to do it."

"I suppose so. But not for me."

Bela's words made sense to Boris and explained a lot. No wonder he had turned down the role. But that only made Boris want it that much more. The thought of reaching the point where you could turn down work was both intoxicating and inconceivable.

A few more cars pulled up in the distance, and Boris turned to see some small, scattered groups of people begin to spread out across the cemetery. "I'll let you have some privacy. A pleasure to meet you."

"Likewise," Bela answered, his gaze back on the headstone.

"Perhaps we will meet again."

Bela turned and looked at him. "Perhaps. One never knows."

Boris gave him a nod and strode away.

Back at his car, Boris climbed behind the wheel. The grave-yard was crowded now, and Boris looked back at Bela, who was the sole figure standing motionless before Chaney's grave. He replayed the conversation, with Chaney's words dancing in his head. Boris had no idea if he could ever find something unique about himself as a performer, something only he could do.

But remembering the screen test brought him some solace. He had gone as deep as possible and left nothing off the table. Would that be enough? Only time would tell. But he knew there was nothing more he could do. He had exposed his greatest fear, the fear that all of this might bring him to the point of wasting away, of being found as nothing more than a decaying corpse, a festering carcass, a rotting failure. He put that out there, and he had literally given a piece of himself to the pursuit.

Buoyed by this, Boris put his key in the ignition and twisted. The car sputtered and gasped, trying to start, but then died. Boris tried several more times, but each time, the engine just wheezed, gargled, and then died.

Defeated, Boris sank onto the steering wheel. *When will it ever end?* he thought. *When?* Leaning back, he tried one more

time, and finally, the engine roared to life. Relieved, Boris dropped the car into gear and drove away.

........

Junior glided across the lot, back toward his office, a man in charge. It was all set. All he had to do was call Whale and give him the good news. Whale had already signed off on Lugosi, so there would be no problems. It was all done, tied up in a neat little package. Lugosi would be the Monster, and *Frankenstein* would be directed by Whale.

Being Sunday, the executive building was empty, and Junior whisked past his secretary's deserted desk and into his office. But even though it was the weekend, the business of the studio went on, and his desk had become a jumbled pile of personal correspondence, production reports, box office numbers, and more. Junior ignored all of it; instead, he gave a big smile to the bottle of Dom Perignon standing proudly amid the clutter, which had been waiting patiently to be opened for the last two days. "Almost time," he said happily.

Junior then began riffling through his desk drawers. It took a moment to find what he was looking for because his secretary handled this sort of thing, but finally, he pulled out a seldom-used phone directory. He placed it atop the mountain of paper in front of him, opened the stiff cover, and began searching for Whale's phone number.

"So, you really are here," a pleased voice pronounced from across the room.

Junior looked up to see Sidney in the doorway, beaming brightly. "Sidney?"

"At your service." She winked. Nothing was said for a short moment. Sidney's eyes narrowed. "Don't tell me you forgot?"

"Of course not," Junior said as he finally remembered the events of the night before. He rose from his chair. "Sit. Sit."

Tossing away her suspicion a bit, Sidney sank down into one of the chairs in front of the desk.

Junior dropped back into his desk chair. "How was the rest of your evening?"

"What do you think, considering my escorts?" she said flatly. "It's nine a.m. I'm here."

"Yes, you are. And I must say, you look fantastic."

"Thank you, Junior."

"Nine a.m., and you are all put together. I'm impressed."

"Junior, you're stalling."

"Who's stalling?"

"You."

"I'm not stalling."

"Okay, then, whaddaya got for me, Junior?"

Junior rubbed his chin. "Yes. What have I got for you?" He stood and began to pace. "Well . . . I've given this a lot of thought," he finally said. "I really have, and I can't seem to find—"

Robert Florey suddenly appeared in the doorway to his office.

"Florey?" Junior asked, surprised.

"You said you wanted to see me first thing in the morning. Sunday. Nine a.m. Remember?"

"Right. Right." Junior mused until it came back to him. Brightening, he crossed the room and majestically offered Florey the empty chair next to Sidney. "Right. Right. Sit. Sit."

Florey quickly sat down.

Junior paced again, this time in front of them both. "I called you both here because I wanted to talk to you about *Murders in the Rue Morgue*. I want you both to know this is very important to me, and I've spent a lot of time on this. Given it a lot of thought." He dramatically stopped right in front of them. "Florey," Junior said as he pointed at Sidney. "I'd like you to meet your leading lady!"

As if hit by a gust of wind, Florey and Sidney both pushed back in their chairs.

"Pretty great, huh?" Junior said, all smiles.

Florey and Sidney both turned and looked at each other. Confusion quickly turned to nodding consent.

"Okay," Sidney said.

"Works for me," Florey echoed.

Junior threw his arms open wide. "Terrific." Coming up behind them, Junior placed a hand on each one of their shoulders. "And you'll both be working with Bela Lugosi, who will be starring in *Frankenstein* too."

"Great." Sidney smiled.

"Wonderful," Florey agreed.

Sidney turned to Florey again. "Junior and I were heading up to Ventura for the polo matches this afternoon. Why don't you come with?" Sidney threw a sly wink Junior's way. "Might make for some nice photos in the rags."

Junior eyed her, smiling. God, he loved her. "Sounds like a grand idea," he quickly agreed.

Florey nodded, completely onboard. "Okay."

Sidney climbed out of her chair. "In fact, why don't we all ride together to the train? Give us a chance to discuss the film."

"Absolutely," Florey quickly answered.

"I have an even better idea," Junior said. "Why don't you two go on ahead, and I'll meet you at the station. I have a few things to finish up before we go."

"Okay, then," Sidney answered.

"Terrific." Florey rose and offered his arm. Sidney took it, and together, they headed for the door.

"We'll see you at the station," Sidney tossed back at Junior. Reaching the door, she paused and looked back at him. "I guess I had it all wrong, Junior," she said appreciatively. "You had it together all along." And with that, she and Florey were gone.

Junior stood in the middle of his office. All alone. It had worked. It had all come together perfectly. And Sidney was right. It would make for some good pictures for the rags. Junior, the new VP of Universal Pictures, with his young starlet on his arm and the director of her next project in tow—at the Sunday polo matches, no less. Just a couple of calls to make, then off to the train station.

He hurried back to his desk and started flipping through his phone book again. It didn't take long before he found the number. James Whale—HY-4943. Junior slid his phone closer, grabbed the receiver, and reached out to dial. But the

receiver slipped out of his hand. He picked it up again, and again it slipped from his grasp. Turning his palms over, he noticed they were slick with sweat, and he wiped them on his sleeve. He grabbed the receiver for a third time, and for a third time, it slipped out of his hand.

Eyeing his sweating hand, Junior collapsed back into his chair. He eyed his other hand; it was sweating too. What was happening? Beads of sweat suddenly sprouted from his forehead. He felt lightheaded, nauseated. Why was this happening? Everything had worked out perfectly. *I'm gonna run the studio myself, no interference. I'm gonna make* Frankenstein. *It's all perfect, just as it should be.*

But as the attack began to overtake him, he began to seethe.

His father's words were causing this. It had to be. His parting shot—about the truth.

"No. I'm not gonna let him win. I was right. Everything worked out," Junior raged as he fought back against the panic attack. He tightened his body and steeled himself, willing it to go away, but it didn't. He felt the turn worsen in his stomach.

Finally, he balled his fists and slammed them on his paper-covered desk.

Clang!

The sound of his hands hitting metal shocked him. Unsure, Junior pushed aside all of the papers, revealing a single round metal object. A canister of developed film. Junior eyed it, confused.

........

They raced through traffic, heading for the train station, chasing and close behind Sidney and Florey's sedan. Junior was thankful for Clancy's past as a bootlegger who used to run moonshine. Like the head and tail of a snake, the two cars weaved and swerved their way along Los Feliz Boulevard. But suddenly, Junior's car made a quick left, heading up into the hills near Griffith Park. Junior hung on to the door handle for dear life and watched Sidney and Florey speed on ahead and away from him. Unconcerned, he turned back, keeping his eyes focused on the road ahead as they raced through the crowded neighborhood.

Junior craned his neck forward, peering out the front window. He pointed. "There it is. Stop! Stop!"

Clancy pulled to the side of the winding road and quickly stopped in front of a spacious Spanish-style house, hidden back from the roadway. Junior leapt out and headed up the front walk, as a studio truck that had been trying in vain to keep up with them pulled up and parked behind the limo.

Junior knocked on the front door. A moment later, it was opened by a butler clad in a tuxedo. "Yes?"

"I'm here to see Mr. Whale."

"Mr. Whale is having breakfast by the pool."

"Great." Junior pushed past the butler and into the house.

"Is he expecting you?" the butler said after him.

Junior didn't answer and quickly rushed through the tastefully appointed house before stepping out onto the back patio. James Whale and David Lewis were seated across from one another at a small white-metal garden table, enjoying a quiet brunch on a typical Los Angeles Sunday.

"Junior?" Whale said, looking up from his newspaper.

"I need to show you something," Junior said, catching his breath. "Now."

Moments later, they were in Whale's spacious living room as a crew from the studio quickly went about blacking out all the windows and setting up a projector and screen. Junior tapped his foot impatiently; Whale watched with a sense of disbelief. After another few minutes, they were done, and after a nod from Junior, the projectionist opened the metal film can that had been on Junior's desk and began to thread it into the projector.

Whale watched as a couple of chairs were rearranged to face the screen, and with this final touch, the room had been transformed into a state-of-the-art screening room. Whale shook his head, amazed.

Junior noticed. "Running a studio does have a few advantages."

Whale climbed into one of the chairs, still taking it all in. "It's unbelievable."

"Not as unbelievable as what you are about to see." Junior pointed at the projectionist, who nodded back to him. The lights in the room were cut, swallowing the room in darkness, followed a moment later by the projector coming to life and blasting the screen with light.

The black-and-white image of a camera slate reading

"Karloff Screen Test" popped onto the screen. A few seconds later, it was gone, replaced by the image of the back of Boris's head, visible from the shoulders up. Slowly, Boris turned toward the camera, inch after agonizing inch of his pale gray face coming into view, until he looked straight on into the camera.

Whale gasped.

"What did I tell you?" Junior said, peering up in awe at the horrifying visage.

"It's . . . it's—"

"Unbelievable?"

"Yes."

Whale squinted. "His cheek. It's so . . . sunken. How did . . . ?"

Junior leaned forward studying the image. The right side of the Monster's face almost had a hole in it, so deep it was almost a skull. Suddenly, a realization washed over him. "My God," he said, astonished.

"What?"

"He removed his bridge."

The two men shared an astonished look and then returned to watching the screen test. With Boris still staring straight into the camera, the shot suddenly became tighter, showing only from the top of his head to the bottom of his neck.

Junior watched, enthralled. It was terrifying. He sneaked a peek over at Whale.

He was nodding and muttering to himself, "Yes. Yes." He was clearly sold. "We must start shooting Monday."

"I would agree."

Then the shot got closer again, his entire face filling the screen. Junior rose up from his chair.

There it was. His chest puffed not unlike a runner bursting through the tape at the end of a race. It was a face that Junior had seen before. Unforgiving. Final. Lifeless. Cruel. And just like his mother's on that horrible day back in New York—hopeless.

He had done it. He had found what he was after. The empires we construct, the lies we tell, the battles we think we win or lose—they mean nothing. There's something far greater out there waiting for us all. No matter how many cities we build. Only one truth. Death.

The horror of it all.

First day of filming
on *Frankenstein*

"The selection of an actor to play the role
of the weird monster in Frankenstein has
finally been made. Boris Karloff has been
signed for this difficult role."

—*8/24/31 Hollywood Daily Citizen*

EPILOGUE

JANUARY 2, 1932

132 days since the first day of shooting on *Frankenstein*

The moment had arrived; the first paying audience was finally seeing *Frankenstein*. Junior paced back and forth in the lobby of the Orpheum Theatre in downtown Los Angeles. As he had every few minutes, he stepped over to a red-velvet curtain that hung behind the back row of seats and through an intentional slit made to accommodate the center aisle, he peered out at the audience. To his delight, through the flickering black-and-white light, he could see the entire packed house easing back into their seats, spent.

It's working; it's really working. And why shouldn't it? he thought as he watched wives ungrasp their husbands, girlfriends loosen their grips on boyfriends, single patrons remove fingernails from seatbacks in front of them. They'd just watched the creation scene, that glorious moment when the crazed Dr. Frankenstein, amid a symphony of sparks and

lightning, brings his creation to life. Junior had damn near destroyed an armrest in the Universal screening room the first time he had watched the complete scene, and every time since, it only got better.

But he knew they weren't out of the woods yet. The big moment was coming. The one that would make or break the entire picture. And he wasn't taking anything for granted. So much so that even though he had brought along the bottle of Dom Perignon, and the theatre was sold out, he would not celebrate; the bottle was still unopened, sitting nearby on a small table next to a pair of empty glasses.

Junior eyed the audience, enjoying the short respite they were given because he knew what was about to happen. They were being lulled back into complacency by a pair of back-to-back static conversation scenes, completely oblivious to what was about to come. They were about to see the Monster for the very first time.

How would they react? Would they be frightened? Would they laugh? Would they stare, confused, at the screen, unsure of what they were watching?

But the truth was, he hadn't left everything to chance. As the first public screening had crept closer and closer, he'd made a big decision. Much to his chagrin, he decided to snatch a dog-eared page from the old man's book. He hired someone, a friend of Sidney's, to ensure the proper response.

So Junior watched closely as Boris Karloff, as the Monster, made his first appearance, backing into the room through a doorframe—Whale had kept this idea from the screen test— before finally turning around to reveal his horrible visage

for the first time. Right on cue, a pretty blonde girl in the third row jumped up out of her seat and screamed. Then, also because it was so effective in the screen test, there were three tighter and tighter and tighter close-ups of Karloff's gruesome face. Still screaming, the pretty blonde ran up the theatre aisle heading for the exit. Approaching Junior, he pulled open the slit in the curtain for her and, after whizzing right by him, he watched as her clattering feet sounded through the marble lobby, and she disappeared out onto the street, hysterical. Junior had asked Sidney to find a good actress, and boy, had she delivered!

Pleased, he turned back to see that her performance had had the desired effect. The crowd was mesmerized, their eyes locked on the screen, as the Monster moved all about, seen in full for the first time. They were utterly terrified. It was working! The film was working! He had done it.

Junior grabbed the bottle of Dom Perignon, ripped off the foil around the top, popped the cork, filled a glass, and took a deep, satisfying drink. From behind, Junior felt a pair of hands slip around his waist and clasp together across his belly. He didn't have to turn around to know it was Sidney, and after refilling his own glass, he filled a second one for her.

Picking up the glasses, he spun around and offered her one. "Thanks. Your friend really did a—"

But Sidney didn't take it and, instead, held out a twenty-dollar bill. "Here ya go."

"What's this for?"

"My friend canceled at the last minute. Here's your twenty back. I'm so sorry. I hope it didn't ruin things."

Junior stared at the bill. It might have been only twenty dollars, but to Junior, it was worth millions. Delirious, he could only manage a bemused smile. "Keep it," he finally said with a wink.

"Okay." She then took the glass from Junior. They clinked, drank, and shared a quiet moment, bathed in the flickering light of Junior's creation playing behind them. Finally, Sidney broke away. "I'm going to find a seat. Coming?"

"No, I think I'll stay back here for a bit longer."

"Suit yourself." Sidney handed back the now-empty glass and held up the twenty. "And I'll hold on to this; perhaps I'll put it toward my trousseau."

Junior shot out a nervous laugh that he smartly discarded for a loving look. Mollified, Sidney slipped away into the theatre, in search of a seat.

Junior watched her go. Sidney was never subtle—trousseau, engagement, a wedding. He knew the issue was always there, just below the surface. But mostly because Junior knew she was right. Something about them just worked, and she would make a terrific bride.

A bride?

His eyes were suddenly drawn back to the screen, and he peered at the image of Karloff lumbering across the screen as the Monster.

A bride? Not a bad idea . . .

Special Thanks

Many thanks to Marna Poole, Jenny Thompson, David Teitelbaum, Craig Koller, David Hoggan, Marc May, Ellen Stratton, Paul Canter, Shannon Kenney Carbonell, Crystal Cartier, Alex Wentworth, Rosemary Laemmle Hilb, everyone at Greenleaf Book Group, Ramsey Stone, and Summer Ramsey.

About the Author

Julian David Stone grew up in the San Francisco Bay Area, eventually relocating to Los Angeles to study filmmaking and then enter the entertainment business. His previous work includes screenplays for Disney, Paramount, Sony, and MGM; the full-length play *The Elvis Test*; and several short-form documentaries on Frank Sinatra for Warner Bros. He is also the writer and director of the hit cult comedy feature film *Follow the Bitch*, which has played to packed houses all around the country and received numerous awards. Recently he began writing books, including his award-winning debut novel, *The Strange Birth, Short life, and Sudden Death of Justice Girl*, about the world of 1950s live television, which is currently being turned into a TV series.

Julian is also the author of the best-selling coffee table book *No Cameras Allowed: My Career As An Outlaw Rock & Roll Photographer*, detailing in words and photos his wild adventures photographing rock and roll concerts in the 1980s.

www.JulianDavidStone.com